IMAGES
of America

CHERRY HILLS
VILLAGE

Members of the Shafroth family and other guests enjoy an elegant afternoon soiree on the west lawn of the Cherry Hills Country Club in 1937. (Denver Public Library Western History and Genealogy.)

ON THE COVER: The Cherry Hills Country Club was established in 1922 by a group of prominent Denver businessmen. Since its founding, it has become the centerpiece of the village and home to one of the finest golf courses in the country. Architects and brothers Merrill and Burnham Hoyt designed the club, which is visible in the distance in this photograph, and incorporated a brick wall entry with meandering brick pattern, decorative and English ball finials, and wrought iron entry arch and lantern. University Boulevard was a dirt road in this 1924 photograph. (Denver Public Library Western History and Genealogy.)

IMAGES
of America

CHERRY HILLS
VILLAGE

Dino G. Maniatis
Foreword by Walter A. "Buz" Koelbel Jr.

ARCADIA
PUBLISHING

Copyright © 2023 by Dino G. Maniatis
ISBN 978-1-4671-0863-8

Published by Arcadia Publishing
Charleston, South Carolina

Printed in the United States of America

Library of Congress Control Number: 2023943125

For all general information, please contact Arcadia Publishing:
Telephone 843-853-2070
Fax 843-853-0044
E-mail sales@arcadiapublishing.com

Visit us on the Internet at www.arcadiapublishing.com

To my parents, George and Isabella Maniatis

CONTENTS

FOREWORD

Throughout history, human settlement and development have followed natural mobility corridors. Early peoples circumnavigated the earth over mountains and oceans, along rivers, and across the open prairie in mule- or ox-drawn wagon trains. Technological advances in rail, air, and vehicular transportation resulted in profound changes in the breadth and scope of these activities, and by the early 20th century, humans could easily travel to all but the most inaccessible parts of the continent by one means or another.

Therein lies the history of Denver and Colorado. The multitudes that came to Colorado in search of gold and silver often utilized multiple transportation methods. The transcontinental railroad bypassed Denver in 1867, but the rail spur from Cheyenne was enough to accelerate the development and growth of the Queen City of the Plains. People also came for reasons other than to strike it rich, homestead, or recover from tuberculosis—specifically, to enjoy and participate in the physical beauty and outdoor wonders of Colorado. Ultimately, air travel continued the advancement and growth of Denver, the Front Range, and the entire state.

As Colorado continued to evolve and expand, a serendipitous collection of dynamics unfolded that created one of the most unique and special communities in the entire country: Cherry Hills Village. Part of this evolution started with what became known as the Valley Highway, a two-lane road between Denver and Colorado Springs that traversed the "high topo," minimizing ups and downs for automobile travel and offering spectacular views of the Rocky Mountains to the west. Its close proximity to the future Cherry Hills Village was ideal.

A group of members from the Denver Country Club, including Alexis Foster and George Gano, envisioned a private golf club south of Denver. The product of their vision became the Cherry Hills Country Club, which was established in 1922 and soon became one of the country's preeminent country clubs. A community and a city grew up around it, and the club's name—chosen by Alexis's wife, Alice, because of a grove of cherry trees situated on a knoll behind the club—was also selected as the name of the city when it was officially incorporated in 1945.

This "club in the country" and the development of the automobile fueled the phenomenon of the country estate at that time, whereby business, civic, and philanthropic leaders of Denver sought refuge from the crowded, polluted city and built elegant mansions near and around the country club. Cherry Hills Village continues to be home to such leaders.

The visionaries of Cherry Hills Village knew that the sprawl of Denver would eventually reach its north border, and as such, they enacted restrictive residential-only zoning and chose not to allow commercial or retail properties within the city limits. This made Cherry Hills Village the only city of its kind in the greater Denver metropolitan area. Since the first zoning regulation was passed in 1939, residents understood and protected the unusual semirural, country environment with larger lots and lower density. It remains that way today.

Valley Highway ultimately evolved into what is now Interstate 25, which carries magnitudes more traffic beyond just normal car trips, including commuter automobiles, business, commerce, and delivery traffic serving the entire region. Equally as important, it became the catalyst for modern visionaries such as George Wallace, John Madden, and Walt Koelbel to establish suburban office parks much closer to residential homes, avoiding the longer commute to downtown. These foundational dynamics all fortuitously came together to create what is now a very special place called Cherry Hills Village.

—Walter A. "Buz" Koelbel Jr.

ACKNOWLEDGMENTS

I am especially grateful to Dr. Thomas Jacob "Dr. Colorado" Noel and the late Honorable Dennis Gallagher—my dear, extraordinary friends who have inspired me and generations of countless others to write the history of the American West. Thank you to Amy Zimmer, friend, historian, and Arcadia Publishing author who introduced this project to the publisher. Thank you to Klasina VanderWerf for her advice and encouragement; she wrote the first book about the city, *High on Country, A Narrative History of Cherry Hills*.

The following institutions opened their archives and cheerfully assisted me: The Cherry Hills Country Club, City of Cherry Hills Village, St. Mary's Academy, Cherry Hills Village Elementary, the Englewood Public Library, Kent Denver, Glenmoor Country Club, Front Range Land and Development, Koelbel and Company, The Village Club, Tufts Chapel, Saint Gabriel the Archangel Episcopal Church, First Plymouth Church, the University of Chicago, the University of Wyoming, the Santa Fe Trail Association, and the *Villager Newspaper*. Thank you to the expert staff at the Denver Public Library Western History and Genealogy Department and History Colorado: Kellen Cutsforth, Martin Leuthauser, Michelle Schierburg, James Rogers, Katie Rudolph, Cody Robinson, and independent archivist Kerry Baldwin.

Writing a book takes a village, and many people were generous with their time and assistance. A sincere thank-you goes to the following: Kristin Freestone-Maniatis, Angelina Maniatis, Kristina Maniatis, George and Isabella Maniatis, Amy Maniatis, Peter Maniatis, Maria Maniatis, Susan Sweeney Lanam, Bob and Gerri Sweeney, Suzanne Bucy, Buz and Sherri Koelbel, Ellie Caulkins, Merle Chambers, Charlie and Judy McNeil, John W. Dick, John W. Dick II, Jeremy Kinney and Holly Arnold Kinney, Eileen Honnen, Mayor Katy Brown, former mayors Laura Christman, Russell Stewart, and Doug Tisdale; Cherry Hills Village City Council, Cherry Hills Village staff, Cherry Hills Village 75th Anniversary Committee, the Quincy Farm Committee, Paula Mansfield, Sister Regina Drey, Meg, Stern, Elyse Rudolph, Pamela Pantos, Richard "Dick" Miller, Peter Shafroth, and Frank Shafroth. A very special thank you goes to Dutch and Pam Bansbach, and Brooke Bansbach Maloy for generously sharing their Cherry Hills Village family history with me through conversations, pictures, and the Bansbach history book.

Unless otherwise noted, the images in this book appear courtesy of the Denver Public Library Western History and Genealogy (DPL), History Colorado (HC), Getty Images (GT), the Englewood Public Library (EPL), Historic Images (HI), and the city of Cherry Hills Village (CHV).

INTRODUCTION

The gold rush of 1859 brought as many as 100,000 ambitious prospectors, speculators, and settlers to Colorado. The mining industry flourished in towns across the state, such as Central City, Black Hawk, Cripple Creek, Aspen, and Leadville, and the industry drew speculators and businessmen. Grubstakers, bankers, real estate entrepreneurs, and a variety of other ambitious fortune-seekers traveled great distances to claim their opportunity. The riches that were extracted from the hard rock bowels of the earth underwrote a "rush to respectability" over the next several decades. Flush with funding and bustling with bravado, developers built opulent hotels, grand opera houses, and mansions and incorporated European architecture into structures throughout Denver and cities around Colorado. They transformed a bawdy, clapboard-strewn mining camp into a city imbued with industry, elegance, and architectural eclecticism—indeed, the largest city between the Mississippi River and San Francisco—by the early 1890s.

The repeal of the Sherman Silver Purchase Act in 1893 signaled the nadir and inevitable end of the Gilded Age. The Panic of 1893 was a national catastrophe that lasted more than three years and marked a significant declension in the Colorado economy. Over 45,000 workers lost their jobs, 12 banks in Denver failed, and the silver mining towns of Aspen and Leadville were hit especially hard, since Colorado mines produced over half of the total silver in the United States at the time. Silver magnate Horace Tabor lost his entire fortune, and Henry C. Brown defaulted on the debt on his year-old Brown Palace Hotel and was eventually forced to sell the property. The panic also affected architecture in Denver. Gone were the elaborate architectural accoutrements of the Gilded Age; architects and builders instead incorporated more austere and laconic neoclassical elements.

World War I, the "war to end all wars," was over before the sunset of 1918, and the dawn of a new decade saw Denver bursting with population growth. The roaring twenties ushered in a new age of wealth and privilege that brought transplants from the East Coast to discover new opportunities in the Queen City of the Plains. Nostalgic for its tony, Gilded Age glory days, well-heeled Denverites vied for respect and standing amongst their peers by shamelessly displaying their wealth. Others who suffered from tuberculosis flocked to the high altitude of Colorado from around the country to bask in the state's 300 days of sunshine and, according to some opinions of the day, drink fresh milk and breathe in the health-restoring odors of cows in order to heal themselves in the regenerative, healthy dry climate. This combination was believed to be a sure cure for tuberculosis, and because of this, Denver soon earned the nickname the World's Sanitarium.

Cherry Hills Village began to thrive and prosper during the roaring twenties. George W. Gano, namesake of the Gano-Downs Department store in Denver, built one of the first mansions in the area, a Tudor located northeast of University Boulevard and Breene (Quincy) Avenue, in 1919. Alexis Caldwell Foster, cofounder of the Cherry Hills Club, constructed his residence on a 160-acre parcel in 1920 just north of Gano; this is now Buell Mansion. The Cherry Hills Country Club began as a humble golf club that soon became the epicenter and destination for affluent emigrants from Denver and elsewhere beginning in the 1920s. Over the next century, the city grew around it.

Development and construction began in earnest in the late 1920s, and the Steck Ranch at the southwest corner of University Boulevard and Hampden Avenue was developed into a high-end enclave of mansions known as Country Homes. By 1938, year-round residents formed the Cherry Hills District Improvement Association (CHDIA, or the Association) for the sole purpose that former mayor Joseph "Joe" Francis Little described in 1963 as "the protection of the area and the prevention of unsightly and inconsistent uses of land." In 1939, J. Churchill Owen led the effort at the Colorado Legislature to adopt a new law authorizing county commissioners to zone unincorporated areas of a county. Following the passing of this law, the Association petitioned the

Arapahoe County Commissioners to enact the Cherry Hills zoning resolution, which effectively covered almost the entirety of the city—an area that would soon become incorporated.

At the end of World War II, George Cranmer, the city of Denver's ambitious parks and improvements manager, hatched a plan to develop a regional airport for freight, cargo, and small private planes. The city purchased 180 acres east of Colorado Boulevard between Hampden and Belleview in the fall of 1944 for the astonishing sum of $43,000; this land had sold for only $4,000 just a few years earlier. This effort was part of a larger annexation plan, known colloquially as the blitzkrieg or the land grab, to extend Denver's city limits to within five miles of the proposed airport so it could legally utilize that land for an airport. In addition, it was reasoned, pilots returning home from World War II would want to fly their own planes for work and leisure.

It appeared that Cranmer and the city of Denver were well within their legal rights to construct an airport. However, lawyers for CHDIA discovered legal precedents in other states with municipalities that had proposed airports close to suburbs and quickly realized that if the area incorporated itself as a town, it could pass an ordinance that set a minimum height restriction for airplanes flying over the city. This impending issue created an immediacy for incorporation, and it was decided that Joe Little, a local lawyer and CHDIA member, should spearhead the effort. The election took place at the Cherry Hills School House, and on February 17, 1945, the city of Cherry Hills Village was voted into existence when it became an incorporated city. Little was elected its first mayor and Louesa Bromfield its first city clerk. Although the incorporation of the city occurred because of Denver's airport plan, Cherry Hills Village never passed an ordinance setting a minimum safe altitude for aircraft.

The budding new city had defeated a land grab from its neighbor to the north, but it still faced several other municipal concerns. The city had no tax revenue, and most of the town had not been platted. Since the homes relied on wells for water, it was determined that lot sizes for over half of the town should be two and a half acres to avoid domestic sewage groundwater contamination. There were commercial districts already in Englewood, Littleton, and Denver, and Cherry Hills Village decided to disallow commercial enterprise so that it could maintain its semirural, entirely residential character. The city approved a master plan that was created in 1950 by noted city planner Saco Rienk DeBoer. His plan placed particular emphasis on the preservation of a semirural environment throughout the city. In 1964, the fire station was constructed, and during this time, the city annexed Cherry Hills East, Mansfield Heights, Southmoor Vista, North Charlou, and several other parcels north of Belleview and east of Colorado Boulevard. In 1966, Cherry Hills Village became a home rule city, and a new charter was approved. The city was now in an official position to self-determine its future.

This is a 1920s view of the cherry trees and "hills" behind the Cherry Hills Country Club—the inspiration and namesake of the club (in 1922) and city (in 1945). (DPL.)

One

THE GHOSTS OF THE PAST

The site of present-day Cherry Hills Village has been inhabited by prehistoric and Indigenous peoples for millennia. Archaeological evidence from the Lamb Spring mammoth site seven miles southwest of the city contains spear points and other artifacts used by early humans at least 9,000 years ago. From the mid-16th century until the mid-19th century, the Dismal River culture hunted and gathered along the plains of eastern Colorado. Known to European settlers as Apaches, they established villages along the South Platte River in and around present-day metropolitan Denver.

The great plains remained unchanged until European settlers arrived and began a half-century period of conquest. The first horses that appeared during the time of the Coronado expedition multiplied and spread across the plains in significant numbers in the early to mid-18th century. Comanche and Kiowa Indians from the north forced the Apaches out of the area, and eventually, these newer arrivals were also driven southeast by the Arapaho and Cheyenne, who lived on the land until well into the 19th century. During this time, Ute Indians lived and hunted in central and western Colorado and often roamed the plains in search of bison.

The Panic of 1819 ushered in the first major economic crisis in the United States. Poor banking oversight, excessive land speculation, and other factors created an environment where businesses failed, prices fell, and banks called in loans en masse. In 1821, soldier, trader, and frontiersman Capt. William Becknell, straddled with debt as a result of the crisis, devised a plan to trade goods for Spanish silver coin, known as specie. Nicknamed the Father of the Santa Fe Trail, Becknell traveled from Franklin, Missouri, to Santa Fe, New Mexico, and returned with $6,000 in coin. The Santa Fe and Smoky Hill Trails became the "interstate highways" of western expansion and enablers of Manifest Destiny. In tandem with other factors, they ushered in a new era of settlement, growth, and prosperity, albeit at the expense of the Indigenous peoples who were displaced.

The US Census Bureau officially closed the western frontier in 1890 because no known tracts of land existed with less than two people per square mile. In Frederick Jackson Turner's controversial 1893 essay *The Significance of the Frontier in American History*, he wrote, "The frontier has gone, and with its going has closed the first period of American history." The ending of the archetypal Old West meant that a decades-long legacy of conquest and subjugation transitioned into a new period of industry and development. The limitless abundance of the frontier faded into the annals of history.

Artist John Gast painted *American Progress* in 1872; this epochal work became the analogue of westward expansion and Manifest Destiny. Columbia, a personification of the United States, leads settlers who travel on foot, on horseback, on wagons, and in steam trains, banishing the fleeing Indigenous peoples and herds of bison. With the Star of the Empire on her head and draped in a diaphanous gown, she strings telegraph wire and brings enlightenment and connectivity from the light skies of the east to the darkness of the west. (Library of Congress.)

The Lamb Spring site is located southwest of Cherry Hills Village. The site was discovered by Charles Lamb on his ranch in 1960 as he was digging near a spring to make a stock pond for his cattle. The Lamb Spring site presents some of the best-preserved evidence of late Pleistocene/early Holocene human habitation along the front range. In this 1961 image, archaeologist Glenn Scott is wrapping plaster bandages on the exposed mammoth bones, including tusks, pelvis, and ribs. Subsequent digs uncovered abundant evidence of human activity around the beginning of the Holocene Epoch around 9,000 BCE. (US Geological Survey.)

This oil painting by artist Daniel MacMorris depicts 34-year-old Capt. William Becknell during his second expedition to Santa Fe, using covered wagons instead of packhorses. He assisted surveyors in creating maps of the Santa Fe Trail, which opened a mobility corridor upon which 300,000 settlers and 1.5 million animals traveled upon over the next six decades. When the Atchison, Topeka & Santa Fe Railroad reached the Colorado border in 1873, its tracks followed the same route that Becknell had blazed a half century earlier. (Santa Fe Collection, Business Men's Assurance Company.)

As early as 1816, mountain men traded with tribes at the confluence of Bear Creek and the South Platte near present-day Cherry Hills Village. American frontiersmen like Jim Bridger hunted, trapped, and discovered new paths throughout the Rocky Mountain west beginning in the 1820s. He led expeditions and created maps from southern Colorado to Canada. Bridger extensively interacted with Indigenous peoples and married women from two different tribes. Like William Becknell, he opened new avenues for westbound emigrants and, in the process, infuriated the Arapaho and Cheyenne, since some of these new arrivals cut through their bison-rich hunting grounds. (DPL.)

The bison roamed the great plains for millennia and numbered around 40 million in the 1830s. Indigenous peoples consumed all edible parts of the buffalo, including the heart, liver, intestines, kidneys, bone marrow, and tongue. The hides were tanned using the animals' brains and made into robes, bags, and wallets. The bones were fashioned into tools such as needles, awls, cups, ladles, and farming implements. In the 1870s, the railroads promoted "hunting by rail" excursions during which thousands of men armed with large-caliber rifles shot buffalo from the moving train purely for sport. Hundreds of thousands of rotting buffalo carcasses littered the prairie as a result, and by the 1890s, the bison had been hunted nearly to extinction. Only a few hundred remained in places like Yellowstone National Park. Their livelihood stripped, Indigenous tribes eventually capitulated to inequitable treaties and were forced onto the reservations. (DPL.)

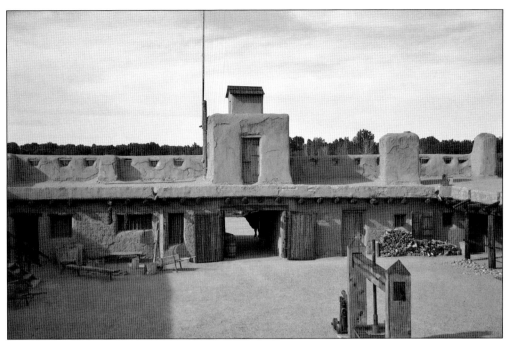

Bent's Old Fort, a significant adobe fort and trading post established by brothers Charles and William Bent and their partner Ceran St. Vrain in 1833, was the only significant permanent white settlement on the Santa Fe Trail between Missouri and Mexico. The fort was the regional epicenter of commerce and cultural exchange among Anglo-Americans, Indigenous people, Hispanics, and others until it was abandoned in 1849. The Bents traded primarily with the Arapaho and Southern Cheyenne for thousands of bison and other animal hides which were eventually sold to customers in the East. Bent's Fort also provided lodging, provisions, wagon repairs, food, water, and protection to thousands of weary travelers. (Photograph by Dino G. Maniatis.)

Western artist George Catlin, in his melancholy reminiscence, eloquently lamented the providence of Manifest Destiny and its profound negative implications on Indigenous people. "I . . . contemplated with the deepest regret the certain approach of this overwhelming system which will inevitably march on and prosper; reluctant tears shall have watered every rod of this fair land; and from the towering cliffs of the Rocky Mountains, the luckless savage will turn back his swollen eyes on the illimitable hunting-grounds from which he has fled; and there contemplate, like Caius Marius on the ruins of Carthage, their splendid desolation." Members of the Arapaho tribe camped along Little Dry Creek and the High Line Canal in the Cherry Hills area until the late 19th century. In the 1880s, Kate Perryman traded high-demand goods such as flour, pepper, and salt with the Arapaho at her farm south of Hampden Avenue along the High Line Canal. (DPL.)

American western photographer and Civil War veteran William Henry Jackson photographed Fort Laramie in the 1860s. The Treaty of Fort Laramie in 1851 partly made the 1859 gold rush possible by guaranteeing safe passage for westward-bound settlers. In 1861, the Treaty of Fort Wise forced the Arapaho and Cheyenne from their lands in Colorado, Wyoming, Kansas, and Nebraska and into considerably smaller territory in southeastern Colorado bordered by the Smoky Hill and Santa Fe Trails on the north and south, respectively. The 1861 treaty, which included parts of present-day Arapahoe County, enabled the unimpeded westward invasion into Colorado and New Mexico. (DPL.)

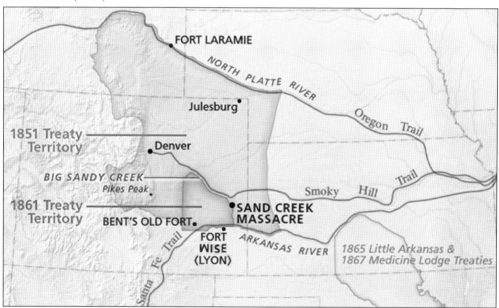

The Treaty of Fort Laramie in 1851 appropriated a vast swath of land between the North Platte and Arkansas Rivers and the Rocky Mountains to western Kansas. The Treaty of Fort Wise was signed in 1861, ceded most of the land granted in 1851, and left the Cheyenne and Arapaho with about one-thirteenth as much territory as they had a decade earlier. Most Native Americans opposed these treaties, as they were signed on behalf of the tribes by only a few leaders and without the consent of a majority. Furthermore, they did not fully understand what was being agreed to, since the treaties were written in English. Additionally, white negotiators shamelessly bribed tribal leaders with wagonloads of gifts in exchange for their consent. (HC.)

Chief Little Raven, the principal chief of the Southern Arapaho Indians, welcomed white "pale faced" settlers to Denver and successfully maintained a peaceful coexistence between natives and newcomers. Little Raven mistakenly believed these newcomers would leave once they had extracted enough gold. Arapahoe County, Colorado's first, was established in 1855, and Arapahoe Streets in Denver and Boulder are named in honor of this tribe. (DPL.)

Denver was a lawless frontier outpost in this c. 1860 picture of Larimer Street. Perched atop a scorched, sedimentary expanse of prairie, the town beckoned eager prospectors who replenished their supplies and morale before embarking on the journey up the hill to the goldfields. (DPL.)

The journey west to Colorado by wagon via the Santa Fe or Smoky Hill Trails took roughly 8 to 10 weeks and was fraught with perils, including starvation, dysentery, breakdowns, and weather. In the 1870s, the railroad largely replaced the animal-driven wagon as the primary means of cross-country mobility. Provisions, durable goods, and even homes could be easily moved coast to coast by train. The railroads largely drove unprecedented population migration into the West during the Gilded Age. (DPL.)

The settler-friendly treaties of 1851 and 1861, coupled with declining economic opportunities in the East, drove ambitious homesteaders, prospectors, and entrepreneurs westward. Here, a group of travelers in Colorado are shown camping on a creek north of Cherry Hills in the 1860s. Groups like this traveled with weeks' worth of provisions, as shown in this campsite, including tools, cookware, weapons, horse tack, clothing, and other personal items. (DPL.)

Over thousands of years, herds of bison rolled around on the prairie and created millions of wallows—shallow, circular topographical depressions that eventually collected water, became ponds, attracted plants, and quenched thirsty animals. (US Geological Survey.)

Speaking about the legitimacy and inevitability of Manifest Destiny, William Gilpin, future governor of Colorado and proponent of expansionism, proclaimed bombastically in 1846: "The untransacted destiny of the American people is to subdue the continent—to rush over this fast field to the Pacific Ocean . . . to establish a new order in human affairs . . . to change darkness into light." Following the end of the Mexican-American War, the United States annexed land from what would become seven states, including California. Decades of inbound settlers ensured the inevitability of Manifest Destiny and had become a fait accompli as the Colorado gold rush brought even more to Colorado in 1859. These "greedy newcomers" arrived in large numbers, crazed with a lust for gold and land and armed with a powerful military force that ensured the eradication of the Arapahoe, Cheyenne, and other Native American tribes, who would soon be forced from their traditional lands by these new arrivals. (DPL.)

The Homestead Act of 1862 offered westbound settlers 160 acres—a quarter section of "unappropriated public lands"—for $1.25 per acre plus a $10 fee. As claims were staked across Colorado and the West, tensions increased with Indigenous tribes and eventually led to conflicts such as the Sand Creek Massacre, which occurred in November 1864. In this image, farmers use horses and manual labor to cut and bundle chest-deep oats. (HI.)

Some early settlers, including women, earned a modest living as hunters. (DPL.)

Two

THE EARLY DAYS

In 1859, gold lured ambitious argonauts from all walks of life to Denver, the Queen City of the Plains, in far greater numbers than the California Gold Rush. In addition to fortune-chasing prospectors who worked the burgeoning mines that dotted the Rocky Mountains, people came to homestead, work on the railroads and in other industries, provide goods and services to an emerging class of gentrified residents, and recover from the scourge of tuberculosis in the dry and sunny, high-altitude climate. The first permanent non-Indigenous arrivals began setting up homes in the area that would become Cherry Hills Village in the 1870s.

Robber baron Jay Gould forced the merger of the Union Pacific and Kansas Pacific Railroads and made plans to construct an extensive irrigation canal in the 1870s. The goal of this ambitious canal was to irrigate more than 70,000 acres of land. Gould enlisted the help of James Duff and Englishman James W. Barclay to purchase 120,000 acres of land along the South Platte River. Duff and Barclay financed the Colorado Mortgage and Investment Company, and its subsidiary, the Northern Colorado Irrigation Company, built the High Line Canal in 1883. Although the canal only irrigated a fraction of the land called for in its initial design, it brought to Cherry Hills people such as John H. Perryman, Cyrus G. Richardson, and the Lipmann family, all of whom established farms near the High Line.

Louis Bartels, a Bansbach family ancestor, purchased a quarter section of land southeast of Quincy and Holly in 1871. In 1874, the Lipmann family purchased 31 acres and a land grant at the northeast corner of Colorado Boulevard and Quincy Avenue for $1 per acre. They built a two-bedroom house near the High Line Canal and adjudicated the water rights on January 18, 1879. J.H.K. Martin, the first president of the Cherry Hills District Improvement Association, purchased the property in 1920 and dug the canal and spring-fed lake. Marjorie Buell, Temple Buell's ex-wife, owned the property for a short time until she sold it to her daughter Callae and Callae's husband, Atwill Gillman, in August 1956. The Gillmans added to the house and built a barn in 1960.

The Steck and Perryman families established two of the earliest farms in the village. James Montgomery Steck and his wife, Sarah Hayes McLaughlin Steck, lived on an 80-acre farm at University Boulevard and Hampden Avenue in 1879. John H. and Kate Perryman purchased 160 acres of land in February 1887, a quarter section that spanned from Colorado Boulevard west about two-thirds of a mile and included present-day Plymouth Congregational Church, First Church of the Nazarene, and the Devonshire Heights neighborhood.

Rufus H. "Potato" Clark, one of Colorado's earliest pioneers, traveled to Denver from Iowa in the summer of 1859 with his wife Lucinda and daughter Mary in an ox-drawn covered wagon. Clark made a fortune and earned his nickname growing, selling, and transporting potatoes to Denver and the mining towns. Clark controlled 20,000 acres of land that included today's Cherry Hills Village and Greenwood Village. The Clark Colony stretched to the southeast corner of Quincy and Holly and was comprised of farmers and ranchers and thrived until the Castlewood Dam located near Franktown burst in 1933, when the Cherry Creek flood destroyed most of the agricultural land downstream. Clark was a known drunk who eventually reformed himself into a generous philanthropist and, among other good deeds, donated 80 acres of land for the University of Denver to move it away from what he called the "moral and environmental pollution" of downtown Denver. Clark and John Evans, the second territorial governor of Colorado and University of Denver founder, established the city of South Denver in 1886. That city's development footprint included what is now University Park and stretched as far south as Yale Avenue. (HC.)

Founder of the *Rocky Mountain News* and tireless promoter of Colorado, William Newton Byers published eloquent stories of prosperous gold mines, bountiful agriculture, and an agreeable climate that were often exaggerated but invariably convinced many to hazard the perilous and arduous eight- to ten-week journey west to Denver. The premiere issue of the newspaper was published on April 23, 1859, a month before the first major gold strike in Central City. It was printed 20 minutes ahead of its competitor, the *Cherry Creek Pioneer*, making it the first paper published in Colorado. In this 1885 image, Byers holds the latest edition of the *Rocky Mountain News*. (DPL.)

The site of a minor gold discovery near Cherry Hills Village at Placer Camp is pictured in 1858 at the mouth of Little Dry Creek. This discovery was the first of several that kicked off the gold rush of 1859. (HC.)

Prospectors panned their way up the foothills to Idaho Springs, where George A. Jackson discovered a substantial placer gold deposit on January 5, 1859, along the banks of Chicago Creek in Clear Creek County. An estimated 100,000 people came to Colorado, on the Smoky Hill and Santa Fe Trails, to stake a claim in the gold rush or land other opportunities in Colorado. Many stayed and settled in Denver. (DPL.)

James and Sarah Steck (pictured) owned this house and 80-acre farm, one of the earliest in Cherry Hills, in 1879, and it became the first subdivision in Cherry Hills in 1922. James Steck's father, Amos, was a judge, legislator, Denver mayor, and school board president. Country Homes (or the Circle neighborhood, as it was known) and the adjacent country club lured affluent Denverites south, where they built lavish country estates beginning the late 1920s. (EPL.)

Construction of the High Line Canal began in 1881 and was completed in 1883. The $650,000 project was meant to irrigate thousands of acres, but the canal had a junior South Platte water rights claim and, as such, could not provide enough water to satisfy demand. At 71 miles long, the High Line Canal flowed through north through Cherry Hills with an average depth of two feet and an elevation drop of two feet for every mile. It was expected to carry 750 million gallons of water per day but delivered only about a tenth of that across the Denver metropolitan area. (DPL.)

The Silver Panic of 1893 snuffed out the exuberance and excesses of the Gilded Age. Since Colorado produced almost 60 percent of the nation's silver, economic recovery was slow, and the first mansions in Cherry Hills would not be built until almost 30 years later. This photograph shows three and a half tons of Colorado silver ingots—worth $85,000 in 1892 (or around $3 million today). (DPL.)

In 1887, John Nelson Perryman's (1921–1990) grandmother Kate (1849–1948) lived on the west side of the High Line Canal, near the present Devonshire neighborhood entrance; his great-grandmother's (name unknown) home was "near the ditchbank [sic], just below the Highline [sic] Canal," and Perryman, his parents John Walter (1885–1956) and Edith G. (née Sedgwick) (1893–1973), and his sister Lois Eleanor (1915–2006) lived between the two dwellings. John and Edith owned the pasture on the east side of the High Line Canal, which she and son John Nelson subdivided after her husband died. Sedgwick Avenue was named after her, and the pasture became the Devonshire Heights neighborhood in 1961. The Perryman and Lipmann families were two of the only permanent settlements along the High Line Canal in Cherry Hills from the 1870s until World War I. (DPL.)

The Perryman farm spanned both sides of the High Line Canal, where there was always an abundance of "fresh frying chickens, asparagus, raspberries, peas, beans out of the garden, currants, black and white mulberries, fresh pork, home-made bread, the aroma of cider as apples from the orchard were fed into the press." (DPL.)

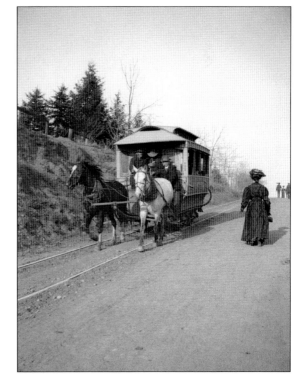

Even though horse-drawn streetcars ferried residents east and west along Hampden Avenue in 1900, pedestrian foot traffic was still common. (DPL.)

Cherry Hills master planner Temple Buell was wounded in a gas attack during World War I, then contracted tuberculosis, moved to Colorado, and convalesced for a year at Bethesda Sanitarium (pictured) in Denver. (DPL.)

This photograph shows the inside of the Agnes Memorial Sanitarium, where the future mayor of Cherry Hills Village, Joe Little, and landscape architect Saco DeBoer stayed when they came to Denver to recover from tuberculosis, the leading cause of death at the beginning of the 20th century. Lawrence Phipps, Cherry Hills Club member and benefactor, spared no expense to build this hospital in 1904 in honor of his mother, Agnes. This state-of-the-art facility was designed to treat "persons suffering from incipient pulmonary tuberculosis." (DPL.)

The black clouds of Denver industry billowed from the smokestacks of plants and smelters that poisoned the air and affected many residents suffering from tuberculosis. In the 1920s, the automobile enabled many to relocate to the cleaner suburbs of Cherry Hills and others south and east of Denver. (DPL.)

Union Station, pictured here in 1894 during its Romanesque Revival period, served four lines—the Union Pacific, Denver & Rio Grande, Denver South Park & Pacific, and Colorado Central. It was the primary transportation hub for moving people and goods in and out of Denver. (DPL.)

With the Pacific Railroad Act of 1862, the federal government subsidized the construction of railroads west of the Mississippi by granting large tracts of land to railroad companies. The Union Pacific and Kansas Pacific Railway Company received more than 100,000 acres of land in the Denver area, much of which was in the area that would become Cherry Hills Village. (DPL.)

Threshers (above) were powered by steam tractors (below). As John Perryman recalled, "Probably my most exciting boyhood memory is of the day the thrashers [sic] arrived . . . the whole farm came alive as the great steam locomotive [tractor] pulled into Grandmother's lane pulling a thrashing [sic] machine followed by an assortment of farm hands [sic] in their jalopies." (Both, DPL.)

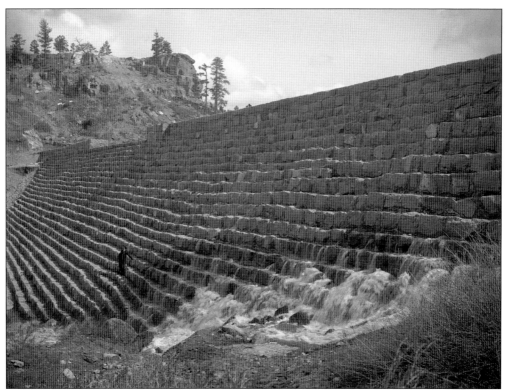

Castlewood Dam is pictured before the 1933 break that flooded the Clark Colony farms in Cherry Hills. (DPL.)

Rufus Clark's Clark Colony was platted into 5- and 10-acre orchards. Water from Castlewood Dam supplied an extensive irrigation system and smaller reservoirs in present-day Greenwood Village. Farmers cultivated fruits and irrigated crops and did so until the Castlewood Dam burst in 1933, causing a disastrous flood. Parcels that previously sold for $500 per acre were liquidated for less than $10 per acre. This land was eventually developed into residential and commercial properties in Cherry Hills Village and Greenwood Village. (DPL.)

This image shows Castlewood Dam after the 1933 break. (DPL.)

The massive flood of 1933 washed out banks and bridges and carried thousands of tons of debris downstream. Forty years later, on May 6, 1973, after several days of rain, another flood caused water to reach four feet deep at University Boulevard and Quincy Avenue. Over 50 breaches in the High Line Canal led to police evacuating Sedgwick Drive for fear of the Welshire dam breaking. (DPL.)

The industrialization of the United States during the Gilded Age dramatically changed the economic landscape. Railroad companies spun a "spiderweb of steel" across the country upon which trains transported people, raw materials, and finished goods with unprecedented speed. The Denver & Rio Grande Western passenger train, engine No. 763, is pictured here near Cherry Hills Village. (DPL.)

The Welcome Arch greeted hundreds of thousands of newcomers to Denver until it was demolished in 1931. (DPL.)

Three

BECOMING CHERRY HILLS

Whether it was the railroad; water; real estate magnates such as John Evans, David Moffat, or Walter Cheesman; or the newly arrived and well-heeled easterners who became wealthy from mining interests and other enterprises, Denver society expanded exponentially from the 1880s through the end of World War I. The Denver Country Club soon became the geographic hub and cultural zeitgeist of Denver aristocracy. But as the upper end of the socioeconomic demographic spectrum grew, so did the rest of its population. In contrast to the architecturally embellished mansions that required dozens—sometimes hundreds—of skilled craftsmen and artisans to build, more modest domiciles were required to satisfy increasing demand. Architectural styles such as the Denver Square, Bungalow, Craftsman, and Foursquare popped up all around the country club after the Panic of 1893, much to the dismay of its more urbane, socialite members. As the city expanded, so too did Denverites' satisfaction with life in the urban setting.

As the Panic of 1893 ravaged the country, so did corruption, crime, and moral depravity in Denver as the city wrestled with rapid growth, understaffed police, and an undercurrent of lascivious behavior unleashed by some of its residents, including excessive drinking, gambling, prostitution, and domestic abuse. To exacerbate this situation, Denverites also choked on the polluted, acrid air belched by the coal-burning steam and electric power plants and smelters around and after the turn of the century. The soot from nearly 200 tons of coal that was burned every day wreaked havoc on the respiratory systems of those who came to Denver seeking to cure tuberculosis, the leading cause of death in the United States at the time. Many Denverites sought refuge in the cleaner and safer sapling-lined suburbs south and east and of the city.

As the city expanded and homes were constructed in neighborhoods east of Broadway after 1900, the density was becoming more and more palpable, and some members no longer felt like they were in the country. One member decried, "The present country club is no longer in the country. It's almost in the heart of town. . . . Like many another institution, the club has outgrown its quarters and been overgrown by the city." Another member bemoaned, "There are too many members and the golf links are overcrowded. . . . Otherwise it's a fine and desirable place." Adding to this was the myriad of other activities that the club offered, including tennis, swimming, skating, dances, teas, and bridge, which limited opportunities to enjoy a simple game of golf.

The Hopkins House, constructed in 1898 for James C. and Grace M. Hopkins, is the oldest surviving home in its entirety in Cherry Hills Village. Although its rectangular design was common in the late 19th and early 20th centuries, architectural embellishments such as multiple dormers that create a story and a half variant and its pedimented entry make this Classic Cottage a rare High Style example. The home is faced with a large, Palladian-style dormer, full-width front porch, red brick facade and belt course, and stone sills and lintels in its main story windows. (DPL.)

George and Ethel Gano built one of the first mansions in Cherry Hills Village in 1919—a 32-room Fisher and Fisher early Tudor design. Exterior details include hand-hewn wood lintels over the doors and windows, a heavy oak-beamed ceiling, leaded glass windows, wrought iron fixtures, a Vermont slate roof, and five fireplaces. Ethel outlived both George and her second husband, Hubert Work. (DPL.)

Dentist William "Doc" Reynolds established KLZ on March 10, 1922, as the first commercial radio station in Denver. Originally broadcasting from Reynolds's home in Denver on south University Boulevard, these two 80-foot towers were relocated and used at Hampden Avenue and Lafayette Street until their removal in August 1961. The towers were a familiar landmark visible from much of Cherry Hills and the location of the controversial proposed Cinderella City shopping mall development in the early 1960s. (University of Chicago.)

Saco DeBoer landscaped the expansive grounds of the 1923 Owen Estate using brick and flagstone to construct walls, walkways, and patios. DeBoer complemented the English manor's yard with a simple rose garden and birdbath vignette. (DPL.)

Because wells and domestic sewage systems needed to be far enough apart to avoid groundwater contamination, building sites in Cherry Hills without access to Denver Water were initially platted at two and a half acres. A crew running a powerful steam drill like this one could bore wells over 700 feet in depth if necessary to supply a clean and reliable source of water for domestic and irrigation purposes. (DPL.)

The county estate became a phenomenon in the 1930s. An article in the *Denver Post* observed, "The love of the country has been the reason for many moving into the country but for others the accessibility to golf links and riding stables has played its part in inducing Denverites with a young family to select suburban locations for their homes." Several turn-of-the-century homesteads and the 104-foot water tower in the Country Homes neighborhood near Hampden Avenue and University Boulevard are visible in this 1930s picture looking northwest. The tower was demolished in 1965. (DPL.)

In less than a decade, the automobile transformed the lives of millions of Americans in unimaginable ways. In 1916, the *Denver Post* reported, "What a revolution the automobile has brought about in all our ways of life and our thoughts. [It] has completely altered the relation of town and country . . . making the farming districts suburbs of our cities." The car transported wealthy suburbanites quickly and comfortably to and from their homes for work and pleasure. Pictured above is a fleet of new Cadillacs in the 1920s. (DPL.)

The Blackmer house, a two-story Colonial Revival, was designed by Colorado architect Roland L. Linder in 1934 for Myron Kerr Blackmer. Now known as Quincy Farm, this agricultural complex originally consisted of 275 acres that Blackmer had assembled and was comprised of many structures including the 1898 Hopkins House. The house is flanked by gabled ends, clad in horizontal wood siding, and has gabled dormers. Linder designed all of the outbuildings except the horse stalls. Born in Nebraska in 1893, Roland L. Linder attended high school in Sterling, Colorado and college at the Universities of Colorado and Michigan. (CHV.)

Suburban population growth necessitated the widening of streets to accommodate increased automobile traffic. On a recently widened street, workers used axes to fell a century-old plains cottonwood. (DPL.)

Mountain States Telephone and Telegraph Company workers labored even during the cold winter months to install poles in the frozen ground, hoist crossbeams, and string telephone wire in order to bring connectivity to customers in Cherry Hills and other suburbs. The cold temperatures called for a winter cover (pictured) to be fitted in front of the radiator of the service vehicle to bring the engine up to the proper operating temperature. (HC.)

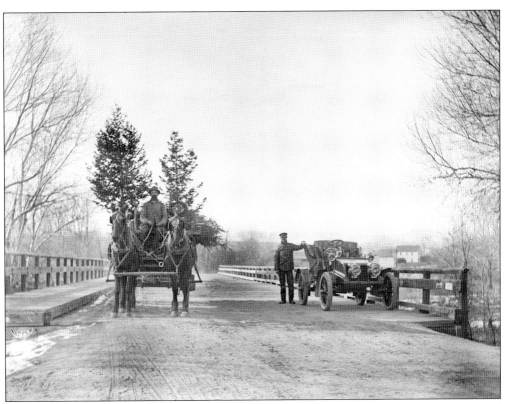

Starting with the blank canvas of the open prairie, landscape architect Saco DeBoer created verdant lawns, gardens, walkways, and treescapes in Cherry Hills using a variety of native flora. These designs called for extensive planting materials that had to be delivered, often by horse and wagon. Here, workers en route to a jobsite with a load of evergreens pass a motorist in an open-top automobile. (DPL.)

The Village Club was originally part of a $3 million federal land grant given to the Kansas Pacific Railway. Florence Kistler and daughters Florence and Frances owned and ran Kistler Stables from 1936 to 1951. In 1937, the *Denver Post* reported the "exodus to the suburbs borders on a stampede" and published a list of wealthy families that established large country estates nearby. Kistler Stables is pictured around 1940 in this view east; Belleview Avenue, on the right, crosses the High Line Canal. (DPL.)

These surplus barracks buildings from Buckley Field were cut in half, transported to the Shafroth property in Cherry Hills at the northeast corner of Belleview Avenue and University Boulevard, and reassembled and used by the family during the summer months. (DPL.)

Louis Bansbach Sr. purchased the old Bartels acreage from his mother and her siblings for $9,600 in 1923. Louis Jr. and sister Charlotte Bansbach platted the property in 1954, and the family built three homes on 2½-acre sites that became the exclusive family neighborhood. What was originally known as the Happy Canyon parcel soon became the Charlou neighborhood, and residential construction began in the 1960s. The surrounding land was used for grazing cattle and horses and for growing wheat until 1950. The Bansbach family annexed the property to Cherry Hills Village in 1967 and was zoned for one-acre sites in Charlou and part of neighboring Chaumont. Two residences and several outbuildings can be seen below the tree canopy in this c. 1930s photograph. Curb and gutter have been installed, and the sign reads "Louis F. Bartels." Louis Bansbach Sr. and his uncles Gustave and Arthur established the Bartels Realty Company in 1924. (DPL.)

Myron Kerr Blackmer, born in Colorado Springs in 1893, graduated from Yale in 1914 and served as a captain in the US Army Corps of Engineers in France during World War I. His father, wealthy oilman Henry Myron Blackmer, was implicated in the Teapot Dome scandal. Myron Blackmer purchased 275 acres of land in parcels between 1922 and 1951. On August 27, 1951, Myron sold the entire assemblage for $300,000 to a group of investors including Mrs. Henry Blackmer, Charles Boettcher III, Ed H. Honnen, Arthur E. Johnson, Will F. Nicholson, J. Churchill Owen, Arthur G. Rydstrom, Nicholas Petry, Aksel Nielson, and (through Nielson) Dwight D. Eisenhower. After Eisenhower became president, he transferred his ownership in the property to his son, US Army major John Eisenhower. Blackmer sold Honnen a separate parcel of 28 acres in 1951 that Honnen called Quincy Farm. (HI.)

The increasing notoriety of the Cherry Hills Country Club attracted the attention of many wealthy Denverites and other prominent figures, including Pres. Dwight D. Eisenhower, who, while on vacation, teed off at Cherry Hills in front of members of the press and onlookers. The KLZ radio towers on Hampden Avenue are visible in the distance. (GT.)

Four

THE CHERRY HILLS COUNTRY CLUB

Denver boomed in the decade following World War I. Multitudes of wealthy easterners flocked to the Queen City of the Plains and built palatial mansions, joined fashionable clubs, bathed in the crystal clear, mile-high climate, and awed at the spectacular natural wonders of Colorado. Denver mayor Robert W. Speer's City Beautiful project, inspired by his European travels, became a national model for city planning and attracted many newcomers to Colorado. The tendrils of urban sprawl spread to neighborhoods around the Denver Country Club, and the increase in surrounding residential density meant it felt less and less like a club in the country. Golfers grumbled about hoofprints and the droppings of polo ponies on the course. Club membership grew, but impatience festered among many members as tee times for a foursome dwindled.

In 1921, a group of its members decided to establish a club without the myriad of social distractions such as tennis, tea parties, bridge, and swimming. The search began in earnest for a new and more exclusive location that could be dedicated only to the sport of golf. The automobile reduced commuting distances throughout the city to 30 minutes or less. The group formed two committees, and each scouted locations along the front range, including the 180-acre Frank Ashley estate in Jefferson County and the 137-acre Skeel family farm and its 15-acre lake, which became the Wellshire County Club in August 1926.

A dinner held at the Denver Country Club on January 25, 1922, reaffirmed the group's plan to establish a "golf club and nothing else—no social life facilities." The group agreed that "[Alexis] Foster and [George] Gano would look for suitable grounds for not only a club but of sufficient size to speculate a little on some residential subdivision alongside." But Foster had already consummated a 50-year lease from C.I. Passover for his 110-acre farm just west of University Boulevard between Hampden Avenue and Belleview Avenue on January 1, 1922. He filed it with the Arapahoe County clerk and recorder on March 16. Foster then assigned the lease to the Greenwood Land Company that he had incorporated just 10 days earlier "for $10 and other good and valuable consideration." It was agreed between parties that the rent would be paid semi-annually at a rate of 6.5 percent of $30,000 or a principal reduction to be paid in $1,000 increments. The land acquisition cost amounted to just $272 per acre.

Once the property had been selected and decided upon, progress occurred rapidly. On February 22, 1922, Foster hosted renowned golf course architect William S. Flynn for lunch at the Denver Country Club. He visited the new site and had drafted a links plan for the southern half of the property. Flynn's philosophy espoused "a really conscientious architect, one devoted to the game and to his profession, will make the club's interests his own. His reputation must rest both on what he accomplishes and in the satisfaction he gives his clientele." Upon review of his plan, club members agreed that "it looks like a top-notch layout with few equals and no superior." On March 28, the club was officially named Cherry Hills Club, so-named by Alexis's wife, Alice, for a small cherry orchard situated on a knoll at the property. The first board of directors was appointed, the articles of incorporation were signed, the Greenwood Land Company took title to the land, and stock was sold to members for $1,000 per share.

A group of members from the Denver Country Club, shown here around 1905, became frustrated with limited tee times, crowded fairways, and a myriad of social distractions and decided to form their own men's-only golf club. In 1922, they identified a large parcel of land only a mile south of Denver. Its gentle, rolling terrain and breathtaking mountain views made it the perfect setting for a new club. (DPL.)

Architects Merrill and Burnham Hoyt's Tudor design for the Cherry Hills Club in 1922 featured an elongated clubhouse, random brick patterned facade, steeply pitched gables, shake shingle roof, leaded and divided light windows, a west facing view of the greens, and a front range panorama. (DPL.)

Merrill and Burnham Hoyts' 1925 renovation plan called for prominent, repeating arched windows, cast stone details, half timbering, and a large chimney. (DPL.)

The fireside room in 1927 featured a stone fireplace mantel with carved wood details, heavy beam wood clad ceiling, and arched windows. (DPL.)

A seating area with mortared stone columns, single pane and divided light windows, wood beam lintel, and a tile floor frames a view of the front range in 1927. (DPL.)

William Stephen Flynn (1890-1945) was a Massachusetts native and the only nonresident member of the Philadelphia School of Golf Architecture, a group of architects responsible for many of the country's great courses during the Golden Age of Golf between 1910 and 1930. He was paid the handsome fee of $4,500 in 1922—approximately $78,000 today—for the Cherry Hills design. (Cherry Hills Country Club.)

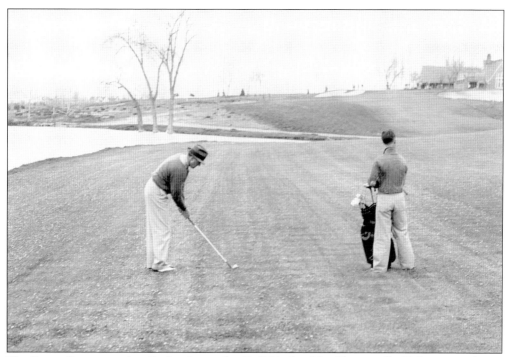

The *Denver Post* reported on Friday, September 7, 1923, that "the Cherry Hills Club, most exclusive of Denver country clubs, moves into the spotlight Saturday. This newest playground of the bluest of Denver bluebloods and the most aristocratic of Denver plutocrats will have its formal opening without any formalities. A cry of Fore, the smack of a swishing golf club against a brand new white pellet and—Cherry Hills will be open." Indeed, the very next day, Alexis Foster drove the first ball from the first hole at 1:00 p.m. With one stroke, September 8, 1923, went down in history as the official opening of the Cherry Hills Club. The 480-yard par 5 on the 18th hole (pictured here in 1938) is where Jack Nicklaus shot par to win the 1993 Senior Open title. (DPL.)

The Depression exacted a heavy toll on golf clubs nationwide. Membership at Cherry Hills dropped from 262 members when this photograph was taken in 1930 to 131 the following year. The 1938 US Open, however, earned the fledgling club $23,000, and golf architect William S. Flynn's course soon became nationally recognized and respected. (DPL.)

On Sunday, August 16, 1942, the Cherry Hills Club made national headlines when it hosted the Bing Crosby, Bob Hope, Lawson Little, and Ed Dudley Golf Tournament to raise money for Buckley Field, Fort Logan, Lowry Field, and Fitzsimons Hospital. The radio broadcast that day generated over $30,000 nationally in addition to the $2,000 that was raised locally from the 6,000 people in attendance. Military servicemembers were admitted to the tournament for free. Briefly, the club gave commissioned military officers an opportunity to join the club for just $2. Twenty-six members from the club joined various branches of the military and were granted leaves of absence to serve in World War II. (GT.)

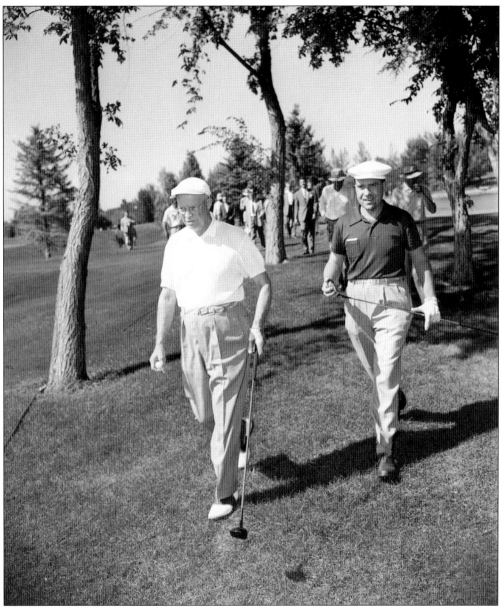

Pres. Dwight D. Eisenhower was a competitive golfer and honorary member of the club. He visited Colorado often and kept in contact with the many friends he made over the years. He and Vice Pres. Richard Nixon enjoy an afternoon of golf at Cherry Hills in the fall of 1953. (GT.)

Bankers at First National Bank of Denver handle over $150,000 in December 1959 for the upcoming US Open at Cherry Hills Country Club. (HI.)

Over 15,000 fans and acres of cars packed Cherry Hills for the final round of the US Open golf championship in 1960. Those who attended witnessed firsthand one of the greatest comebacks in sports and the most iconic day in the history of golf. (GT.)

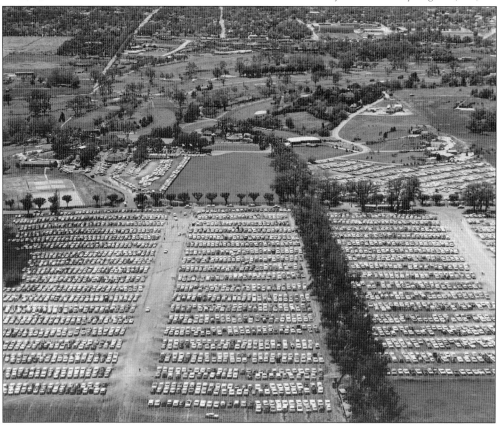

A national folk hero was born on June 18, 1960. In the fourth round and in 15th place, Arnold Palmer erased a jaw-dropping seven-stroke deficit to top Jack Nicklaus, Mike Souchak, Dow Finsterwald, Jerry Barber, Ben Hogan, and Sam Snead and win $14,400 in the US Open at Cherry Hills with a score of 280. Palmer once remarked, "Golf is deceptively simple and endlessly complicated. It satisfies the soul and frustrates the intellect. It is at the same time rewarding and maddening—and it is without a doubt the greatest game mankind has ever invented." (DPL.)

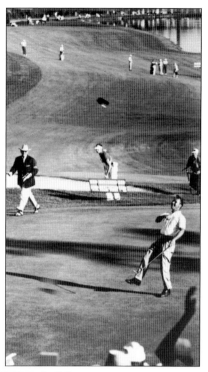

The Cherry Hills Country Club team was leading the 1966 Gold Cup when this picture was taken. (DPL.)

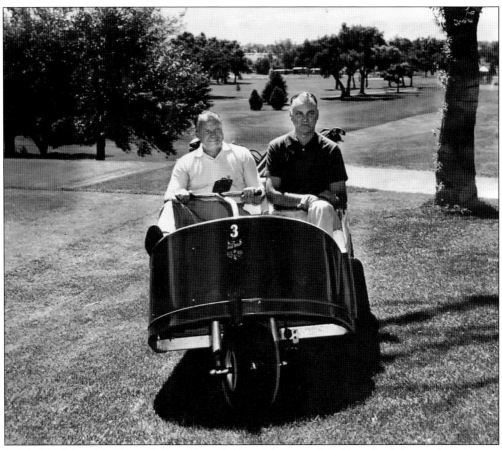

Ralph "Rip" Arnold, Cherry Hills golf pro (left), and J. Kernan Weckbaugh, club president, inspect the course in an electric golf cart in preparation for the 1961 Hillsdilly. (DPL.)

Ben Hogan (center) observes Jack Nicklaus's swing at the 1960 US Open. (DPL.)

Vail Ski Resort owners Pete Seibert (far left) and Robert Murri (second from right) watch Steve Knowlton (center) assess his next shot at Cherry Hills in 1965. Seibert and Knowlton served together in the US Army's 10th Mountain Division in Italy, where Seibert was wounded by a mortar shell at the Battle of Riva Ridge in 1945. (GT.)

Aviation pioneer Elrey Borge Jeppesen (left), creator of Jepp charts, golf superstar and 1960 US Open champion Arnold Palmer (center), and Jeppesen Aviation president and former US Army Air Corps P-47 Thunderbolt fighter pilot Wayne Rosenkrans (right) enjoy an afternoon of golf at Cherry Hills Country Club in 1974. (E.B. Jeppesen collection.)

Gene (left) and Walter Koelbel are pictured at the 50th anniversary celebration of the Cherry Hills Country Club in May 1972. Walter chaired the gala that year and was president of the club from 1969 to 1970. (Koelbel family.)

Five

A City Is Born

By the 1930s, many homes had been constructed east and west of the University corridor between Hampden Avenue and Belleview Avenue for prominent residents such as Alexis Foster, George and Ethel Gano, Merritt Gano, J. Churchill Owen, William R. and Persis Owen, the Shafroth family, Al and Louesa Bromfield, and James Benton Grant Jr. Other properties were scattered throughout the area, including the Perryman, Martin, Bansbach, Burnett, Blackmer, and Rable homes. In 1939, the Cherry Hills District Improvement Association (CHDIA) was established for the express purpose of "protection of the area and the prevention of unsightly and inconsistent uses of the land." Attorney J. Churchill Owen drafted and introduced a law that allowed Arapahoe County Commissioners to zone unincorporated areas of Cherry Hills and prevent commercial and multifamily properties.

New development and construction projects were placed on hold while the nation was at war from 1941 to 1945, but as the war neared an end, Denver announced its intention to build a regional airport. This announcement was predicated by the purchase of a large tract of land east of the schoolhouse. The CHDIA mobilized to prepare a defense strategy. Despite Denver's seemingly ostensible right to proceed with the airport project, the CHDIA discovered a legal precedent that an incorporated city could pass an ordinance establishing a minimum operating altitude for aircraft. Threatened with this possibility, Denver dropped its plans for an airport. After the hasty incorporation of the city in 1945, this ordinance was one of the first proposed, but ironically, never was adopted. Instead, the city passed an ordinance on July 3, 1945, that "provides that the office of Cherry Hills Village shall be located in the Cherry Hills Schoolhouse, East Quincy Avenue and South University Boulevard, Cherry Hills Village, Colorado."

Over the next 30 years, Cherry Hills Village expanded, became a home rule city, and dealt with several other substantive municipal issues. In the 1960s, in an effort to prevent Denver from annexing land north, east, and south of the city, Cherry Hills annexed Charlou, Cherry Hills East, Mansfield Heights, Southmoor Vista, and a few parcels in the Belleview corridor. This added almost 600 new residents and enlarged the city's footprint by over 30 percent. The city's total property valuation in 1967 was $11,350,000, and its annual budget was $199,000. In 1971, Cherry Hills Village residents were successful in blocking construction of an Interstate 25 interchange at Quincy Avenue. Several parks were dedicated in the 1980s, including Three Pond (1985) and Woodie Hollow (1989). In 2002, residents voted to exclude the city from the South Suburban Parks and Recreation District.

By the 1910s, power plants like the University Park Railway and Electric Company (visible in the distance) had infrastructure in place to begin supplying early suburban customers including those in Cherry Hills, through miles of electric poles. Broadway is the dirt road in the foreground. (DPL.)

Cherry Hills was almost completely undeveloped south of Hampden Avenue in the early 1920s, and only a few country estates existed throughout the village. Louis Bansbach Sr. and Claude S. (C.S.) Baker, a well-known and trusted local farmer, ran a dry land wheat and livestock operation that included cattle, dairy cows, sheep, and chickens. Together, they farmed 800 acres of their own land in addition to 640 acres of leased land (pictured) that belonged to Myron Blackmer and George Gano southeast of Quincy Avenue and Colorado Boulevard and northeast of Quincy Avenue and University Boulevard, respectively. (DPL.)

Cherry Hills Village founders held in-depth discussions about allowing stores and service establishments. Since there were business districts in nearby Denver, Englewood, and Littleton, there was no need for the city to have its own. This 1937 image shows a southward view of the Englewood business district at Hampden Avenue and Broadway. (EPL.)

In 1945, Cherry Hills Village enacted Zoning Ordinance No. 9 of 1945, which created three residential districts from a half acre to two and a half acres. Numerous streets that were deemed unnecessary were vacated in 1960. The resulting semirural density of this zoning can be seen in this 1967 aerial view looking northeast from the Old Cherry Hills neighborhood. Landmarks include the Cherry Hills Country Club, the 40-acre Shafroth property that would become Cherrymoor, St. Mary's Academy middle right edge, and the village center, upper right. (CHV.)

Lawyer Joseph F. Little was elected the first mayor of Cherry Hills Village in 1945. When Little came to Colorado in 1927, he was suffering from an advanced stage of tuberculosis and was not expected to survive. Nonetheless, like Saco DeBoer and many others who came to Colorado, he was treated at Phipps Sanitarium in Denver and recovered. Little worked tirelessly to fend off the development of a regional airport proposed by the city of Denver. In a letter dated October 5, 1955, Cherry Hills Village mayor George J. Stemmler wrote in a letter to his predecessor, Joe F. Little: "One cannot think otherwise when they think back to 1945 when this area was a 'sitting duck' for the strong annexation policy of our neighbor to the north. It was largely through your efforts that Cherry Hills came into being. . . . Our future is bright, too, as a result of your efforts." Stemmler lauded Little's efforts to stave off Denver's attempt—led by George Cranmer, the city's parks and improvements manager—to construct a regional airport on 180 acres the city had purchased east of the Cherry Hills schoolhouse. (HI.)

The philosophy of Saco DeBoer's 1950 master plan stated, "The incorporators have given it the name of 'Village,' thereby expressing their desire to permanently keep the rural atmosphere which exists there today. . . . The rolling topography is such that it lends itself to become a residential park rather than a crowded city addition . . . it will be necessary to design the whole area as a park." DeBoer's innovative plan made efficient use of existing land contours, which reduced the need for excessive cuts, fills, and bridges and substantially lowered infrastructure construction costs for the recently incorporated city. His planning expertise produced U-shaped and no-thoroughfare streets, which meant quiet, peaceful neighborhoods that children and families could enjoy. Furthermore, he planned few or no parallel streets and funneled traffic along through the major traffic arteries along Hampden Avenue, Belleview Avenue, and University Boulevard. (HC.)

Before Joe Little became the first mayor of Cherry Hills Village, he and his wife, Jane, constructed this home in 1941. Tudor elements such as decorative half-timbering, steeply pitched roofs, and intersecting gables were popular at the eve of World War II. This is the only residential project that architects Gordon Jamieson and R. Ewing Stiffler designed. Saco DeBoer created a landscape plan that was more informal and parklike. (DPL.)

Saco DeBoer lived in this 1931 red brick Tudor from 1920 to 1974, and here he created extraordinary landscape master plans for cities throughout Colorado, including Cherry Hills Village in 1950. (DPL.)

By 1949, the city had two full-time employees: city clerk Louesa Bromfield and city marshal Jess Briddle. Peter Dominick, World War II Army veteran, future Colorado senator, and ambassador to Switzerland, volunteered to be the first city attorney. Temple Buell became chairman of the Planning Commission. Saco DeBoer was hired to design the master plan, and the following year, he submitted his proposal, which sited city hall at the village's approximate geographic center at University Boulevard and Quincy Avenue. The unique, enameled red street signs were installed in 1950 based on the hue of the bright red pumps that Bromfield wore to official meetings. Architect Stanley Morse worked for Burnham Hoyt and designed the Cherry Hills Village Center. The hexagonal blonde-brick structure, built in 1963, housed the city's administrative offices. (Both, CHV.)

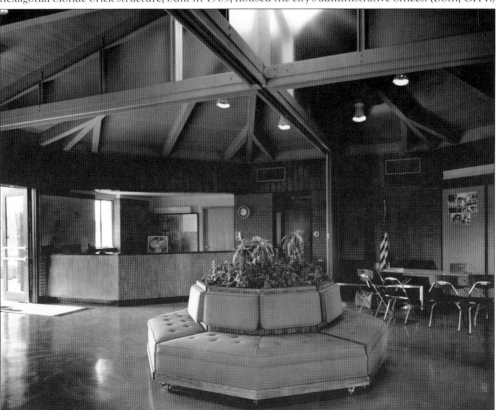

CHERRY HILLS VILLAGE, COLORADO

September 20, 1955

Board of Trustees of Cherry Hills Village
c/o Mrs. Elizabeth Noel

Dear Trustees:

My doctors have told me that I simply must cut out a lot of activities. It is not a question of taking a rest now, but they tell me I have been doing entirely too much. I am, therefore, resigning as Mayor of Cherry Hills Village, effective at once.

I want to thank each of you for your splendid help and cooperation in making the Village the success that it is.

Sincerely yours,

Joseph F Little

JFL:sc

Upon the advice of his doctors, Joe Little resigned from his position as Cherry Hills Village's first mayor in 1955 after 10 years of elected service. (CHV.)

Certificate Of Occupancy
Cherry Hills Village Colorado

Issued without fee.

869

AUG 19 1963

Permission is hereby granted to CHERRY HILLS VILLAGE
(owner or lessee) to use the _____ floor of the
ONE story building, situated at 2450 E QUINCY
Lot _____ Block _____ Addition _____
for the following purpose VILLAGE CENTER
_____ Floor load not to exceed _____ Lbs.

TAKE NOTICE
No change shall be made in the use of this building without prior notice and certificate from the Building Inspector.

This certificate shall, except in the case of dwellings or churches, be so conspicuously posted in or upon the premises to which it applies that it may readily be seen by anyone entering such premises.

Jean L Braucht
Chief Building Inspector
Cherry Hills Village, Colo.

Cherry Hills Village opened its new city hall building in August 1963. (CHV.)

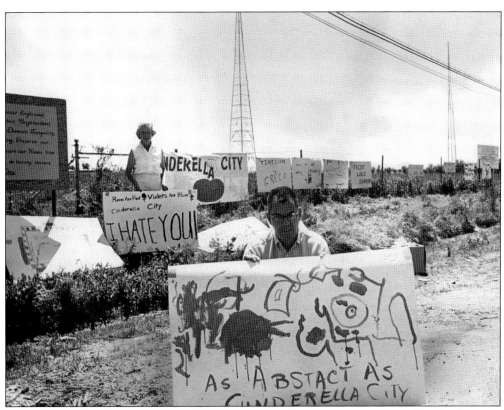

Time Incorporated, owner of the KLZ radio tower site, weighed in on the mall redevelopment proposal in August 1960: "Suburban sprawl defies good local land planning and mocks good local land planners. The need for bigger and better planning is obvious everywhere. But what chance do far-sighted planners have against the profit motive working full blast in reverse and offering quick profits on bad land use?" Protesters of the proposed 55-acre Cinderella City rezoning site stand amidst 97 posters painted by local youth at Hampden Avenue and Lafayette Street in June 1961. (GT.)

This eight-by-six-foot zoning sign, the largest ever in Englewood, was displayed at the northwest corner of University Boulevard and Hampden Avenue, the proposed site of Cinderella City shopping center, in 1961. In order to avoid certain zoning restrictions, it was cleverly called a "regional shopping center." The proposal was a hotly debated and contentious issue for Cherry Hills Village residents. (GT.)

ZONE CHANGE REQUEST

PRESENT ARAPAHOE COUNTY (OR CHERRY HILLS ZONING DISTRICT) ZONING
IS 'R-A-2' OR 'CHERRY HILLS DISTRICT H'
WHICH CLASSIFICATIONS ARE BOTH RESIDENTIAL

APPLICANT REQUESTS ANNEXATION
TO THE CITY OF ENGLEWOOD
TO BE ZONED FOR USE AS A REGIONAL SHOPPING CENTER
AS A C-3 DISTRICT
IN ACCORDANCE WITH THE PROVISIONS OF
ORDINANCE NO. 10, SERIES OF 1961,
AMENDING ORDINANCE NO. 45, SERIES OF 1955.

PUBLIC HEARING ON REQUESTED
ZONING WILL BE HELD AT
ENGLEWOOD HIGH SCHOOL FIELD HOUSE
3800 SO. LOGAN ST.
ENGLEWOOD, COLORADO
8:00 P. M.
MAY 11, 1961.

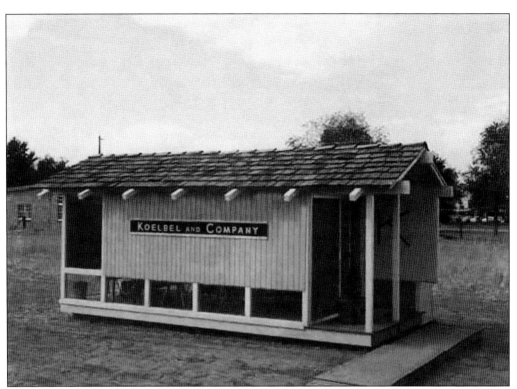

Walter Koelbel established Koelbel and Company in 1952 as a residential brokerage company that soon became a land development firm. Early in his career, Koelbel recognized the investment potential of land south of Denver, particularly around country clubs, and began assembling parcels of land in Cherry Hills Village. Beginning in this modest structure, Koelbel developed five subdivisions in Cherry Hills in the 1950s and 1960s. (Koelbel family.)

This 12-foot-diameter, 48-foot-long surge tank weighing 50 tons is pictured en route from Eaton Metal Products in Denver to the Cherry Hills Pumping Station. It and a 100-ton tank were installed in 1970 to hold up to 20 million gallons of water and decrease the likelihood of catastrophic infrastructure damage due to sudden or unexpected increases in water pressure. (GT.)

The $620,000 Cherry Hills Pumping Station at south Franklin Street and Radcliff Avenue was built in 1962. The postmodern design with an overhung roof blended with the existing residential architecture of the neighborhood. (GT.)

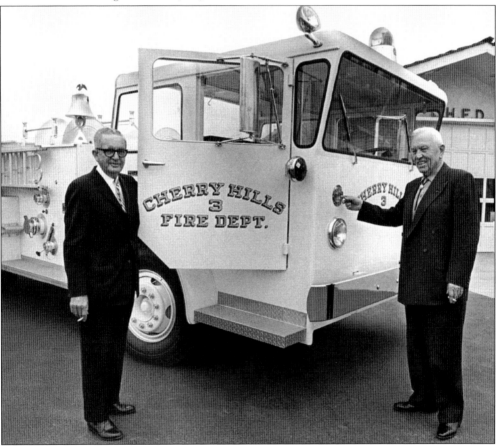

The Cherry Hills firehouse was originally built in 1964 south of the village center. Bill Butler (left), secretary of the city's Fire Protection District, and fire chief R. George Woods are pictured enjoying a smoke in front of the district's new American LaFrance pumper truck at the firehouse on University Boulevard. The truck boasted a capacity of 750 gallons and cost $25,192 in 1967. On staff were five paid firefighters and Chief Woods. There were two fires at the village center alone. The first, in 1970, was caused by a police car that had rolled in an accident that day and another started in 1973, with the cause unknown. (GT.)

The west half of Cherry Hills Village is pictured in 1963, the year that University Boulevard was widened to four lanes. Geographical landmarks include the Country Homes subdivision, Cherry Hills Country Club, Buell Estate, Devonshire, Lynn Road, Cherry Ridge, and vast swaths of undeveloped land, including Cherry Hills Park, Cherrymoor, and Cherry Hills Farm. In 1908, the southwest corner of the city (now known as Old Cherry Hills) was subdivided into the 150-lot Swastika Acres subdivision. The name was changed over a century later in 2019. (CHV.)

In 1966, a charter for the City of Cherry Hills Village was approved, and the city's status changed from a statutory town to a home rule city. The following year, a merger was proposed between Cherry Hills Village and nearby Greenwood Village. Although the majority of Cherry Hills residents voted in favor of it, the proposal failed, as Greenwood Village residents voted to deny the merger. (CHV.)

Cherry Hills Village was included in the Arapahoe County 911 service in February 1976. In 1977, city council amended the charter to create a council/city manager form of government, and in 1990, the US Post Office authorized the city to use "Cherry Hills Village" as the mailing city of record. Pictured here are Cherry Hills Village police officers and a K-9 unit in 1975; from left to right are unidentified, Jerry ?, unidentified, and chief of police Chuck Wood. (CHV.)

Mayor Richard Schrepferman (left) and William J. Matsch, president of the CHV Sanitation District, observe the start of work on a $3.7 million sanitation project in 1976 that would service about 65 percent of the city and begin the process of consolidating its existing 38 utility districts. (GT.)

Six

SCHOOLS

In 1886, James Steck, secretary of the board of education for Arapahoe County, recorded a decision that established the Breene Avenue School, the first in the area. On the first page of the minutes, in his elegant calligraphy, he wrote, "At a meeting held at Steck's Ranch March 25th, 1886, for the purpose of forming a new School District, Richard Beeson was elected president and James Steck, secretary." Among those in attendance was local John Perryman, and two days later, it was made official. The Breene Avenue School was constructed in 1887 adjacent to the dirt path that would eventually become Quincy Avenue. Tuition was set at $3 per student per quarter, and arrangements were made with other districts for the transition to high school.

On December 5, 1898, local farmer Arthur B. de Koevend loaned the school district a frame building free of charge for use as a branch school near University and Quincy. In 1900, however, both the Breene Avenue School and this branch school could not meet the needs of the community, and a new school was built; it opened in September 1900 at the exact location of present-day Cherry Hills Village Elementary. This brick structure, known as the new school, caught fire in December 1930 just before a Christmas program. Because the building was heavily damaged, school was held at two nearby residences, including the Baker/Rable residence at Quincy and High Streets, until it was rebuilt a year later in the same location.

St. Mary's Academy, the oldest private school in Colorado and one of the oldest in the state, traces its origins back to 1864 at its first location in Denver. When then-father (later bishop) Joseph Projectus Machebeuf arrived in Denver on October 20, 1860, there were approximately 3,000 residents in Denver, among which were only 10 Catholic families and a large handful of about 200 people who were considered devoted followers. Machebeuf purchased a large, two-story frame house downtown, and St. Mary's held its first classes in August 1864. As Denver grew, it became apparent that a location outside of downtown would be better suited for a school setting. Margaret "Molly" Brown, *Titanic* survivor and friend of Mother Pancratia, recommended that the school purchase several vacant lots next to her home. With Brown's financial support, a cornerstone ceremony was held at St. Mary's Academy's new location at Fourteenth and Pennsylvania in January 1910. In 1951, the Hickerson Georgian Colonial home was renovated into 12 classrooms, a chapel, and a convent for 18 sisters. In 1964, for St. Mary's 100th anniversary, Helen Bonfils donated $500,000—half of the total cost—for a new high school building.

The Cherry Hills School is pictured here in 1887. At the northeast corner of Breene (Quincy) Avenue and University Boulevard, inside a one-room schoolhouse, one teacher taught all grades of kids from the surrounding farms. The first teacher was Isabel Phipps, who taught first through eighth grades but soon resigned since she could not find a place to live near the school. For the first 12 years, the teacher's salary began at $40 per month but later increased to $55 per month. Despite the increase in pay, attrition was high due to a variety of reasons, including "marriage," "family responsibilities," "a position with a higher salary," "a chance to better herself," and "she will not teach school anymore." Some claimed lack of satisfaction. (Cherry Hills Village Elementary.)

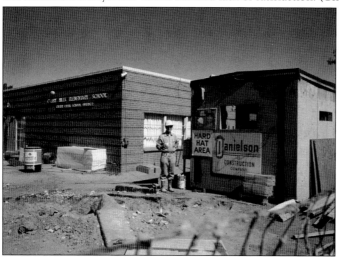

The word "Elementary" was not added to the Cherry Hills School until 1955, when seventh and eighth graders began attending Cherry Creek Junior-Senior High School. The school has undergone several renovations, including this one in the 1980s. (Cherry Hills Village Elementary.)

Fr. Joseph Machebeuf arrived in Denver in 1860 and established churches across the state. He announced the opening of St. Joseph Hospital, the first private teaching hospital in Colorado, which was founded in 1873 with only $9. Machebeuf purchased the house where St. Mary's was established in 1864. Among his many remarkable accomplishments, Machebeuf announced the opening of St. Joseph Hospital, the first private teaching hospital in Colorado, founded in 1873 with only $9. He purchased the house where St. Mary's was established in 1864. By the time Machebeuf died on July 10, 1889, there were 64 priests, 102 churches and chapels, 9 academies, 1 college, 1 orphanage, 10 hospitals, and 3,000 children in Catholic schools in the Diocese of Denver, and 40,000 Catholics in Colorado." (DPL.)

Fr. Joseph Machebeuf purchased the George W. Clayton residence for $4,000—a large, two-story frame house at the corner of Fourteenth and California Streets. On August 1, 1864, Srs. Joanna Walsh, Ignatia Mora, and Beatriz Maes-Torres opened the first "select school for girls," known as the White House by locals, for 20 boarders and several day students. (St. Mary's Academy.)

St. Mary's Academy student Jessie Forshee was the first high school graduate in the Colorado Territory in 1875, a year before Colorado became a state. She became a Sister of Loretto whose religious name was Sr. Mary Vitalis. (St. Mary's Academy.)

In her March 1864 journal entry, Sister Joanna described the immense difficulties of establishing a new school on the frontier: "We had to do everything ourselves. No help to be had then . . . we had . . . to apportion all the housework and cooking, and reserve time for our spiritual exercises." (St. Mary's Academy.)

Titanic survivor Margaret "Molly" Brown recommended and donated to the purchase of several lots next to her Capitol Hill mansion for St. Mary's Academy's new location at Fourteenth and Pennsylvania Street in 1911. For the next 40 years, the Pennsylvania Street Campus survived tumultuous global events that caused enrollment to drop and made resources scarce, including World War I, the Great Depression, World War II, and the beginning of the Korean War. Talks of expanding the school began in earnest in the postwar years. Sr. Georgetta Hoermann, the superior at that time, led a search committee that considered options with enough land for sports fields, outdoor activities, and a larger, more flexible campus. The F.W. Woolworth Company purchased the campus in 1951, and the school moved to Cherry Hills Village. (DPL.)

On September 18, 1922, the Kent School for Girls opened its doors with 82 students and 13 faculty members in this Georgian Revival mansion at 933 Sherman Street in Denver's Capitol Hill neighborhood. It was named for founding principal Mary Kent Wallace. (Kent Denver.)

The Kent School for Girls relocated to its new campus at the northwest corner of Hampden Avenue and University Boulevard in January 1951, the approximate location of the present-day King Soopers. (Kent Denver.)

Denver Country Day School was established in the former Brown Mansion at Dartmouth Avenue and University Boulevard in the fall of 1953. (Kent Denver.)

Allan R. and Lorena Hickerson constructed a Georgian Revival mansion (pictured) soon after they purchased the property in 1937. Allan died in 1948, and Lorena sold the estate to St. Mary's Academy in 1951. The school completed construction on the new grade and high school building in 1953. Hay bales are scattered across what is the present-day Cherrymoor neighborhood (center). Landmarks in this 1953 aerial photo include the c. 1915 James Rable house on Quincy Avenue and High Street in the top center and its pump house to the west along Little Dry Creek, the 17th hole at Cherry Hills Country Club, and University Boulevard at the bottom of the image. (St. Mary's Academy.)

Andrews D. Black, left, soldier in the US Army 10th Mountain Division during World War II, and friend Tom Chaffee, conceived of an idea for a boys' school. After months of planning, the two secured a location and established Denver Country Day School in the fall of 1953 in the former Brown Homestead at University Boulevard and Dartmouth Avenue. (Kent Denver.)

Madeline Albright (center) graduated from the Kent School for Girls in 1955 and became the 64th secretary of state of the United States in 1997, was a United Nations ambassador, and worked as a professor at Georgetown University. (Kent Denver.)

The last separate graduations for Kent and Denver Country Day schools were held in the spring of 1974. That fall, the newly combined school held its first fully coeducational day of classes. From then on, it was known as Kent Denver. (Both, Kent Denver.)

By the mid-1960s, Kent Denver and Denver Country Day School had outgrown their respective facilities in Denver. The school merged with Kent Denver and agreed to jointly purchase the 200-acre Blackmer Farm on Quincy Avenue where it operates today at its new campus, pictured here during construction in 1967. (Kent Denver.)

Anne H. La Tronico began working as a teacher at what was then Cherry Hills School in 1935 and became the school's principal in 1951—a position she held until her retirement in 1972. La Tronico increased the number of teachers from 4 to 20 and school rooms from 5 to 20. She was so beloved and respected in the community that the La Tronico Center was named in her honor in 1973. The school's philosophy is contained in the 1974 dedication brochure: "This is a building for children, to live, to learn, to love, to think, to relate, to create, to share, to explore, to wonder, and most of all to become themselves." (GT.)

Seven

THE VILLAGE PEOPLE

The history of Cherry Hills Village features a cast of characters from disparate places and walks of life who created a city, established recreational clubs, and founded educational institutions. From individuals like Pres. Dwight D. Eisenhower, who brought national attention to the Cherry Hills Country Club, to the multigenerational clans such as the Bansbachs, Honnens, Koelbels, and Shafroths, who raised families and built infrastructure and communities, these people shaped the city's identity and created the idyllic, semirural aesthetic that still remains today.

For almost a century and a half, spanning seven generations, the Bansbach family has been an integral part of Cherry Hills, Denver, and Greater Colorado history. The Bansbach family immigrated from Germany in 1848 and eventually settled in Denver when Anthony Bansbach (1851–1884) married Bertha Bartels (1859–1953) in Denver in 1880. Their children Louis Phillip "Dutch" Bansbach Sr. (1881–1949) and sister Antonia Bansbach (1884–1982) became the first generation of Bansbachs in Colorado. Louis Sr. married Margaret "Madre" Dake (1889–1974), a Colorado native, heiress, and only child of Alvin C. and Charlotte Dake. Their children Louis Phillip "Lou" Bansbach Jr. (1914–1996) and Charlotte (1912–2004) were early landowners and developers in Cherry Hills. The Bansbach family owned land in the eastern portion of the city near Hampden and Dahlia and a quarter section from Quincy Avenue and Happy Canyon to I-25 and Belleview Avenue. The original 19th-century, 51-acre Bansbach family homestead is being developed into Belleview Station, a mixed-use development and transportation hub in the I-25 corridor. It has remained in continuous family ownership for over 125 years.

Morrison and Abby Staunton Shafroth purchased a summer cottage and a 150-acre alfalfa farm with two other couples at the current site of Cherry Hills Farm and Glenmoor Country Club in 1926. They enlarged the house and added heating, insulation, and other necessary upgrades. The Shafroths later purchased 40 more acres at the southwest corner of University and Quincy. The families alternated their use of the property from spring through fall. Since there was no central heat in the farmhouse, it remained vacant during the winter months. A well-known philanthropist, Abby Staunton was one of the original founders of the Graland School in Denver in 1927.

Walter A. Koelbel, born in 1926 in Muskegon, Michigan, founded Koelbel and Company as a real estate brokerage firm in 1952 at the age of 26. In 1954, Koelbel began two developments—Charlou on east Quincy Avenue and Cherry Ridge, an 80-acre neighborhood of 77 lots at University Boulevard east of St. Mary's Academy. Like many early Cherry Hills Village communities, Cherry Ridge did not initially have municipal infrastructure and therefore depended entirely on well and septic. In 1956, Koelbel developed Cherryvale, which consisted of 50 lots west of Woodie Hollow Park, many of which backed up to Little Dry Creek. Koelbel and Company began developing Martin Lane in 1958, a 30-lot development on the west end of Cherry Hills Country Club. In the early 1960s, development commenced at the Mansfield Heights subdivision at Dahlia and Mansfield Streets, where 120 homes were constructed on approximately 60 acres. In order to develop this parcel, Koelbel assembled hundreds of 25-by-125-foot former Clark Colony lots and spent incalculable hours researching records and purchasing lots one by one from individuals and estates. In the mid-1990s, Koelbel and Company developed a portion of the former George Gano estate into Cherry Hills Park, 24 two-and-a-half-acre sites that set the high watermark price for lots sold within Cherry Hills Village. After Gano, subsequent owners of the property included Dwight D. Eisenhower's estate and Clifford Roberts, Eisenhower's friend, and cofounder of the Augusta National Golf Club in 1933 and Masters Tournament in 1934.

In 1882, James Benton Grant became the first Democratic governor of Colorado. Born in Alabama to a wealthy family, he served in the Civil War as a private in the 20th Alabama Light Artillery Regiment of the Confederate army. Grant's son James B. Grant Jr. was one of the earliest members of the Cherry Hills Country Club. Grant Sr. built a Neoclassical home in Denver, now known as the Grant-Humphries mansion, and his son built a Fisher and Fisher–designed Tudor in the Country Homes neighborhood in 1928. During his life, Grant Sr. and his wife, Mary Goodell, were prominent figures in industry and society. He served on the boards of or cofounded the Denver Board of Education, Denver National Bank, Colorado Women's College, and the Colorado Scientific Society. (HC.)

Louis Phillip Bansbach Sr. understood that urban sprawl would reach his farm near I-25 and Belleview Avenue and, hence, opposed the construction of an interstate highway, as it bisected his property and would prevent him from moving farm equipment from one side to the other. Bansbach played football at East High School, became quarterback at Stanford University in 1900, and married Margaret Dake, known as Madre in the family. He partnered with well-known farmer Claude S. Baker, and together, they farmed 1,440 acres of property they owned or leased east of University between Hampden Avenue and Belleview Avenue. (Bansbach family.)

Cherry Hills city planner, renowned architect, philanthropist, and cofounder of the Cherry Hills Country Club, Temple Hoyne Buell (1895–1990), saw combat in France as a US Army 1st lieutenant in the 101st Trench Mortar Battery, 26th Infantry Division, American Expeditionary Force. Buell received the Distinguished Service Medal for engagements at Soissons, Seicheprey, Flirey, and Belleau Wood and for the Battle of Château-Thierry, where he was seriously injured by phosgene gas in 1918. Buell soon thereafter contracted tuberculosis and moved to Denver in 1921 to receive treatment and convalesce at Bethesda Sanitarium for a year. In 1923, he founded T.H. Buell and Company Architects, a design/build firm that specialized in residential, commercial, and public buildings. He is best known for his development of the Cherry Creek Shopping Center in 1955. Buell also designed and/or built over 300 structures, including his Art Deco masterpiece, the Paramount Theater, which was erected in 1930. (National Cyclopedia of American Biography.)

Merritt Gano built one of the earliest houses in the Country Homes subdivision at the former Steck Ranch at the southwest corner of University Boulevard and Hampden Avenue. (HC.)

In 1919, George Gano built one of the first homes in Cherry Hills, a Tudor designed by noted architects Fisher and Fisher. Proprietor of the Gano-Downs department store, George was one of the cofounders of the Cherry Hills Country Club in 1922. (HC.)

From left to right, Denver mayor Robert W. Speer, Pres. Theodore Roosevelt, and Colorado governor Frank Shafroth are pictured at an event in Denver in 1910. (DPL.)

The Bansbach family is pictured here in 1947. They are, from left to right, (first row) Dake Fisher Warren, James Warren, Robert Warren Jr., Lynda Lee Bansbach, Louis P. "Dutch" Bansbach III, Margaretta Keyes, Frances Keyes, and ? Keyes; (second row) Robert Warren, Charlotte Warren, Lucille Bansbach, Louis Bansbach Jr., Louis Bansbach Sr., Bertha Bartels Bansbach Fishel, Gilbert Fishel, David Main, Antonia Bansbach Main, Margaret Dake Bansbach, Betty Main Keyes, Gretchen Main Davidson, and Donald Davidson. (Bansbach family.)

Physician and Cherry Hills resident Hubert Work served as postmaster general, secretary of the interior, president of the American Medical Association, and chairman of the Republican National Committee. As secretary of the interior, in 1924, Work formally granted citizenship to Native Americans in the United States who did not already have it. He also served as a lieutenant colonel in the US Army Medical Corps during World War I. He married widow Ethel Reed Gano in 1933 and lived in Colorado until his death in 1942. (Library of Congress.)

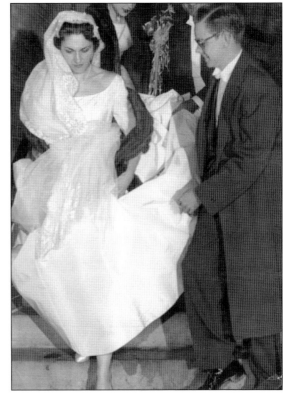

Allan and Lorena Hickerson purchased a 10-acre site on south University Boulevard from Morrison Shafroth and H.G. Hixon for $10,000 in 1937. They built a Georgian Revival home and lived there until St. Mary's Academy purchased it and relocated in 1951. (HI.)

In 1922, real estate developer Henry C. VanSchaack, president of the VanSchaack Company and one of the Cherry Hills Club's original directors, established the Country Homes Land Company in 1922, a 120-acre residential development at the former Steck Ranch at the southwest corner of University Boulevard and Hampden Avenue. The first lots were located at the south end of the subdivision closest to the club and ranged in size from one and three-quarters to two and a half acres. The subdivision was located at the northern border of the country club and was within walking distance of the club. (HI.)

Developer Walter Koelbel, who founded Koelbel and Company in 1952, enlisted in the US Naval Reserve in 1944 and attended the University of Colorado in Boulder, where he played tight end for the Buffaloes, served as team captain in 1946, and graduated from the School of Business in 1947. In 1954, Koelbel purchased a large tract of land at the eastern edge of Cherry Hills from early residents Charlotte and Louis Bansbach. The property was divided into two and a half acre sites that were sold for between $5,500 and $6,500. The community's name, Charlou, is a portmanteau of its previous owners. (Koelbel family.)

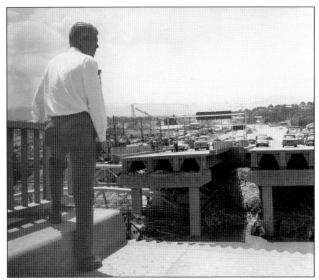

Extreme meteorological conditions including exceptionally heavy rains, high winds, and hailstorms caused one of the worst natural disasters in Colorado history on June 16, 1965. The South Platte River flooded, claimed 24 lives, and caused over $543 million ($5.2 billion today) in damage across the Denver metropolitan area. Peter Dominick, US senator, Cherry Hills resident, and the first Cherry Hills Village city attorney, stands atop the Hampden Avenue bridge and assesses the catastrophic carnage. (EPL.)

Cherry Hills Village resident and concert promoter Barry Fey turned down the opportunity to add an unknown English band to his first Christmas concert lineup on December 26, 1968, at the Denver Auditorium Arena that featured headliner Vanilla Fudge and opening act Spirit. Recognizing the young band's immense potential, Vanilla Fudge offered to pay Fey half of their own booking fee for the night—$750—and Fey agreed. That night, Led Zeppelin played its first concert in North America and made rock-and-roll history. The soon-to-be iconic rock group posed for a photo in London just days before they left for their milestone performance in Denver. From left to right are bassist John Paul Jones, guitarist Jimmy Page, singer Robert Plant, and drummer John Bonham. (GT.)

Attorney, Denver Tech Center developer, and telecom pioneer John W. Dick and his partners successfully launched a constellation of Ka-band satellites into medium earth orbit that provided high-speed, low-latency internet access, voice, and data to approximately three billion underserved customers across the globe. A longtime Cherry Hills resident and Rolls-Royce collector, he is pictured at his Country Homes estate with his 1962 Rolls-Royce Phantom V Limousine. (Dick family.)

On September 23, 1955, Pres. Dwight "Ike" D. Eisenhower enjoyed a hamburger with onions for lunch after a round of golf at the Cherry Hills Country Club. Ike complained to his physician later that evening about what he believed to be indigestion. The next day, a cardiac specialist determined that the president had suffered an anterolateral myocardial infarction. For almost seven weeks following his heart attack, Eisenhower convalesced on the eighth floor of Building 500 at Fitzsimons Army Hospital in Denver and ran the country from a small hospital room until he was released on November 11—Armistice Day. (GT.)

Ed Honnen, owner of Honnen Construction and a Colorado Caterpillar and John Deere equipment dealer, was a lifelong lover of horses and a true cowboy who "loved the traditions of the American West." Honnen graduated from Colorado College in 1921, and in 1963, he donated $750,000 to the school for an open air ice rink. Ed and his wife, Marnie, purchased the 28-acre property that he named Quincy Farm in 1951 from Myron Blackmer. The Honnens lived there until they sold Quincy Farm to Keith and Catherine Anderson in 1964. (GT.)

Eight

ARCHITECTS AND ARCHITECTURE

Architect Sir Edwin Landseer Lutyens, considered by many to be the greatest English architect since Sir Christopher Wren, once said, "There will never be great architects or great architecture without great patrons." Colorado's preeminent early and mid-20th century architects, including Merrill and Burnham Hoyt, Fisher and Fisher, and Edwin Francis, created vernacular examples of great architecture in Cherry Hills Village. Early designs, such as Alexis Foster's Georgian or George Gano's Tudor, were inspired by traditional European architecture, and later examples included Burnham Hoyt's progressive Art Deco and modernist Internationalist Style interpretations, such as the Barrows' residence in 1938. These pioneer architects created the collective aesthetic of Cherry Hills Village and inspired the next generation of architects.

William Ellsworth Fisher (1871–1937) and Arthur Addison Fisher (1878–1965) designed four of the most prominent historic homes in Cherry Hills Village—two for George and Merritt Gano, a grand Tudor for James Benton Grant Jr., and banker Alexis Foster's home (now Buell Mansion). Fisher and Fisher's work in Cherry Hills Village is characterized by Georgian and Tudor inspired architectural elements, including exquisitely detailed elevations with elaborate brick facades, windows, and cornices.

Merrill H. Hoyt (1881–1933) began his architectural career as a draftsman for architect William E. Fisher in 1899. Merrill encouraged his younger brother Burnham, a draftsman for another Denver firm, to attend the Beaux-Arts Institute in New York City. Soon thereafter, they formed M.H. & B. Hoyt Architects in 1919 and worked together until Merrill's death in 1933 from a heart attack at the age of 52. During his career, Merrill and Burnham designed several prominent homes and buildings, including the Denver Press Club and Lake Junior High.

Burnham Hoyt (1887–1960) was a Denver native who graduated from North High School in 1904. Hoyt served in the US Army for two years, designing camouflage in France during World War I. The two brothers designed the Cherry Hills Country Club in 1922 and the Maitland Estate in 1925. After Merrill's death in 1933, Burnham's first solo project was the 1936 Bromfield Residence. This design catapulted Burnham Hoyt into an esteemed status among the first generation of Colorado modernist architects and was featured prominently in national publications. His last project in Cherry Hills Village was the 1938 Barrows Residence.

Architect Edwin A. Francis (1905–1966) designed his Tudor home at 3200 East Quincy Avenue in 1952 and several other similar homes in Cherry Hills Village, the J. Gordon Bent/LeMoine Bechtold/Allan Jr. and Mary Louise Hickerson home at 4201 South University Boulevard (1939), the Ethan A. Young home (1941), the Albert Brooks home at 3 Lynn Road (1945), the William Allen home on Cherry Hills Drive (date unknown), the Thomas L. Howard home (1948), the first addition to St. Mary's Academy, and additions to the Cherry Hills Country Club in 1960.

Settlers built rudimentary homes on the frontier with notched logs and chinking to seal out water, air drafts, and pests. Simple lean-to structures used dimensional lumber and were a simple and inexpensive way to construct shelters and outbuildings. Homes like this around the area were situated near waterways such as the High Line Canal or Little Dry Creek, where there was a plentiful supply of trees, surface water, and an alluvial fan from which rudimentary well pumps like the one pictured could provide water for domestic and livestock use. (DPL.)

Banker and cofounder of the Cherry Hills Country Club Alexis Caldwell Foster and his wife, Alice, hired architects Fisher and Fisher to design an exquisite country home evocative of the estates and plantation houses of his native Tennessee. A Colonial Revival design totaling over 14,000 square feet was created and situated on the highest point of their 160-acre property that enabled an unobstructed panoramic view of the front range. Built between 1919 and 1920, the mansion featured symmetrical side gables, Flemish bond brickwork, gabled dormers, and two pairs of massive end wall chimneys. Saco DeBoer, city planner and iconic landscape architect, designed a whimsical array of manicured lawns, a curved entry driveway, flower and vegetable gardens, fountains, stone pathways, sculptures, and lily ponds. (DPL.)

Following his arrival from Europe, Saco DeBoer found American cities to be ugly, where "one continuous, monotonous Main Street seems to stretch from Atlantic to Pacific." He planted shade trees and flowers along streets, created verdant esplanades, and experimented with a variety of indigenous flora. DeBoer worked extensively with Denver mayor Benjamin F. Stapleton on city parks, parkways, and urban planning. An example of his landscape design in Cherry Hills is seen in this view south from the Foster Estate shortly after its completion in 1920. (DPL.)

Merrill and Burnham Hoyt drew upon traditional European styling to conceptualize the Cherry Hills Country Club, including meandering brick, a prominent gabled facade, and wrought iron windows in this late-1920s photograph. (DPL.)

Businessman John T. Barnett, born to a devout Catholic family in New York in 1869, moved to Silverton, Colorado, where he taught school, became its superintendent, and owned a newspaper. After graduating from law school in Chicago in 1896, Barnett moved back to Colorado, where he served as Ouray County attorney. In 1908, the Democratic Party celebrated its victory in the newly constructed Denver Municipal Auditorium (now the Ellie Caulkins Opera House), with John F. Shafroth elected governor and Barnett elected Colorado attorney general. Barnett was a pro-labor union politician who chaired the Colorado Democratic Party from 1912 to 1916 and was a national committeeman from 1913 to 1928. In 1932, he lost the US Senate nomination to former Colorado governor Alva Adams. Barnett had become very wealthy with his oil and gas interests in Colorado and Wyoming. His connections to oilmen involved in the Teapot Dome scandal, however, likely prevented him from being nominated by Pres. Franklin D. Roosevelt as the envoy to Canada in 1935. Barnett's Cherry Hills residence (pictured) was designed by Harry James Manning in 1925 and featured a prominent central tower with entry, tile roof, and arched and Italianate windows. Manning was known for his innovative sanitarium designs, including Bethesda in Denver, with its open-air rooms and moveable partitions. He created plans for many other prominent buildings in Colorado, including the Mary Reed Library, Byers School, and the Boettcher, Reed, and Moffat mansions. (DPL.)

In 1923, Merrill Hoyt designed his residential crown jewel, an English country estate for William Roland Owen Jr., co-owner of the Denver Dry Goods Company, and his wife, Persis McMurtrie Owen, on South Gilpin Street. William served as a captain in the 334th Field Artillery Regiment in France during World War I. Saco DeBoer landscaped the expansive five-acre estate with gardens, flagstone patios, brick walkways, expansive lawns, and terraced walls. A hexagonal tower with latticed parapet is flanked by a steeply pitched primary gable entry, hip and gable roof lines, heavy copper gutters, and an elegant circular drive. The estate featured a functional windmill and water tower with a vertical storage tank, which are pictured at right. (Both, DPL.)

This is a view of the west elevation of the Maitland mansion shortly after it was constructed in 1925. Telephone poles behind the house run north and south and mark University Boulevard. Prominent gables and half-timbering dominate most of the facade that features brick banding, a five-sided, flat-roofed bay window, and a two-story end wall chimney that accommodates a fireplace on each level. A low brick wall around the perimeter encloses an elevated and grassed open patio area. Built for prominent Denver industrialist James Dreher Maitland, it was the only historic home in the city constructed in the half-timbered Tudor style. (DPL.)

The Shafroth family purchased this quaint, double gabled summer cottage, situated on the hilltop where Cherry Hills Farm is today, from Lucius Hallett in 1926. A fire destroyed most of the house in 1959, but it was rebuilt exactly as it was a year later with the addition of a south master bedroom. The expensive oriental rugs that were stored in the garage avoided destruction. (DPL.)

Fisher and Fisher hand-drafted this Norman architecture–inspired 1928 Tudor masterpiece for Denver attorney James Benton Grant Jr. Grant attended school at Phillips Andover Academy, Yale University, and Harvard Law School. He was chairman of Potash Company of America and Denver National Bank and vice president of American Crystal Sugar Company. The home is oriented around a three-story circular tower and features steeply pitched hip roofs, intricate brickwork, and a Vermont slate roof. Interior details include a Jacobean ribbed plaster ceiling in the living room, wormy chestnut paneled library, circular travertine staircase with hand-wrought iron balustrade, and plank catwalk at the top of the tower. (DPL.)

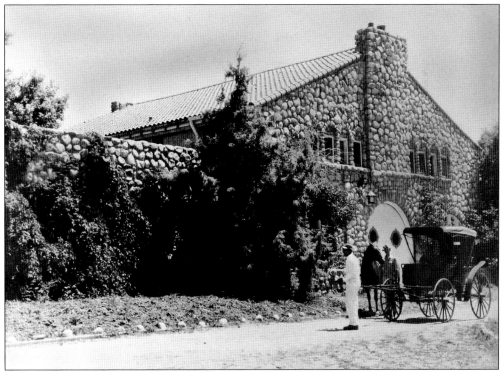

On Friday, January 22, 1937, Florence Kistler hosted a Midnight Feast to celebrate the completion of her Temple Buell–designed stable building (pictured), which is now the Village Club. (Village Club.)

Cripple Creek native J. Churchill Owen, namesake of law firm Holme, Roberts & Owen, drafted and introduced legislation authorizing county commissioners to zone unincorporated areas of a county, specifically for the area that became Cherry Hills Village in 1945. Merrill and Burnham Hoyt designed his Tudor mansion in the Country Homes subdivision Subsequent owners were Robert Six and Ethel Merman Six, oilman John M. King, and developer Bill Walters, who razed the house. The original elevation (pictured) featured a steeply pitched rooflines, a prominent central tower, stucco cladding, partial half-timbering, slate roof, and twisted brick chimneys. (DPL.)

Painter Herndon Davis was mobilized to Denver as a US Army private to help keep the peace during the Denver Tramway workers' strike in 1920. The Army recognized Davis' artistic talent, and he was soon sent to Washington, DC, where he drafted secret maps of Japan and China. Davis painted thousands of works, including *The Face on the Barroom Floor*, commissioned by Central City Opera in 1936, and portraits of Douglas MacArthur and Franklin D. Roosevelt, who sent thank-you letters acknowledging his work. Davis's Cherry Hills home is shown as it appeared during his lifetime on south Ogden Street near Hampden Avenue. (DPL.)

These images feature exterior views of the Alfred J. and Louesa Bromfield residence, designed by Burnham Hoyt and constructed in 1936 on South University Boulevard near Belleview. The hue of the red street signs in the city was based on the shoes that Louesa wore to official city meetings in 1950. The Hoyt design incorporated cube shapes, angular and rounded walls, simple brickwork, a flat roof wrapped with wood and glass brick walls, and a large second-story terrace. In the foreground are a sloped lawn and tulip beds. (DPL.)

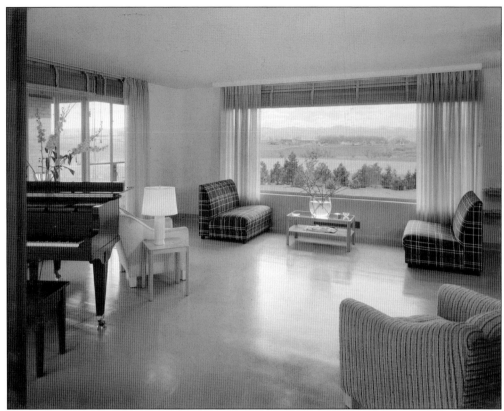

The 1938 Burnham Hoyt–designed John S. Barrows home enjoyed a panoramic front range view from the living room. (DPL.)

In one of his more modern designs, architect Burnham Hoyt used simple geometric shapes for this unidentified 1940s Cherry Hills Village residence. (DPL.)

Nine

THE VILLAGE COMMUNITY

In the November 1960 *Village Crier*, a resident elucidated the reasons for living in Cherry Hills Village:

> We live here because we sought a return to a more elemental pattern. We sought a country life, a simplicity, a serenity, a kind of neighborliness which has, of recent years, faded from much of the urban scene. We need to see our children come home breathless and glowing, a new-found bird's nest clutched in a grubby hand; we like to plant our roses and anxiously watch our gardens grow; we love the quiet night noises; we rejoice in the pale green smells of spring and the pheasant's raucus [*sic*] call. There is no one here who has not stood motionless on a summer morning absorbing the meadow lark's golden song. We come and go singly—our individuality remains totally intact—but when one of us need help, aid is very close at hand.

Since even before its incorporation, Cherry Hills visionaries and city planners recognized the importance of proper land use, overall aesthetics, and long term protection and preservation. Saco DeBoer emphasized the importance of legacy and offered this advice for future generations:

> We must not stop in our planning for beauty. Our trees and parks and gardens must be renewed constantly if we are to leave a decent world for those who follow us. Now is the time to plan that world. The city grows so fast that it will soon be too late if the opportunities for making it beautiful are not grasped now . . . an atmosphere of peace, an air of quiet . . . to the poor, driven creature of today, a simple footpath, muddy underfoot, perhaps, but quiet overhead, might be a real Godsend . . . Our present civilization needs these spots out-door quiet more than it needs anything else, and it may be that the next generation will have accommodated themselves still less to the mechanical age and will need them still more than we.

As many as 75 of these Maddox wagons brought fresh ice every day from Denver to the refrigeration plant near Broadway and Hampden Avenue, a luxury available nearby to families who lived in Cherry Hills during and after World War I. Iceboxes were commonly used to store ice until freezers and icemakers became widely available in the 1950s. (EPL.)

This 1950 photograph, taken from Temple Buell's property, formerly the Foster Estate, looks northwest across what is now the Buell Mansion neighborhood and includes a view of the 104-foot-tall, 150,000-gallon water tower in the Country Homes subdivision. The KLZ towers on Hampden Avenue are visible at right.

In his memoir, John Nelson Perryman remembered, as a young man, seeing many groups of people on the family farm in Cherry Hills, including squatters, Dust Bowl refugees, tent dwellers, "the wandering bands of mysterious and romantic gypsies," and the Ku Klux Klan, which burned crosses on their property. In an effort to solicit John's father, the KKK offered him a hood and a membership; however, the elder Perryman "ordered the Klan and their crosses off our property never to return and, to my knowledge, they did not." (DPL.)

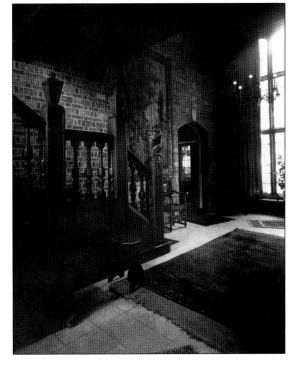

Exposed brick walls, a hand-carved wood staircase, tile floors, and floor-to-ceiling windows characterize the interior of the George Gano mansion in this 1920s photograph. (HC.)

This image shows the inside the sunroom at the Foster residence (present-day Buell mansion). The stock market crash of 1929 and resultant financial malaise caused the Foster family to move to New York soon after the crash. In 1935, Alexis Foster's friend Temple Buell and his wealthy socialite wife, Marjorie, purchased the property, renaming it SanMar (combining Temple's nickname, Sandy, with Marjorie). The Buells raised four children there until 1958, when they divorced, and the mansion was boarded up and left vacant for 30 years until Temple Buell renovated it from 1988 to 1989; he lived there until his death in 1990 at age 94. (DPL.)

This c. 1925 picture of the entry to the Wellshire Country Club near Hampden Avenue and Colorado Boulevard shows Denver and Cherry Hills, including a rutted dirt road, hay bales, and large cottonwoods along the horizon. (DPL.)

On December 14, 1896, Apostle John W. Taylor boarded a Denver-bound train in Salt Lake City with the express purpose of founding a new mission of the Church of Jesus Christ of Latter-Day Saints in Denver. Many faithful saints followed Taylor in the years that followed, and by 1923, the Englewood Branch at 3000 South Pennsylvania Street had been founded by a group of Mormon families from Tennessee, a ward that served the community for 17 years, until the Cherry Hills Ward was established in 1960. The first president of the LDS Englewood Branch was Morris Samuel Robinson (right), who is pictured with counselors Virgil E. Gray (center) and Dan J. Denning (left) in 1923. The chapel was dedicated on October 24, 1926. (Tufts Chapel.)

Pictured looking east is Cherry Hills Village as it appeared from Clarkson Street near Quincy Avenue in 1946. One of the two prominent water towers in the city is visible in the distance between two farmhouses on Stanford Avenue between Lafayette and Downing Streets. (EPL.)

On May 23, 1955, Bishop Hanson R. Robinson purchased a three-acre parcel in Cherry Hills Village for $7,000, and construction of Tufts Chapel began in earnest in August 1958. The building was designed by architect B.E. Brazier of the firm Ashton, Evans, and Brazier, based in Salt Lake City, Utah. Brazier's design focused specifically on the best combination of aesthetics, utility, and economy. Members of the newly formed Cherry Hills Ward generously donated their time and money toward the construction of the new chapel. Member and superintendent Fred Schaffer oversaw the construction during several frozen winter months of foundation work and the muddy spring that followed. Harold Silver of Silver Steel donated all of the structural steel, doors, and windows that were used in the construction of the building. According to church doctrine, "No indebtedness or mortgages are allowed, and no building is dedicated until it is entirely paid for." By the time the entire project was completed, it had already been completely paid off. Elder John Longden, assistant to the Council of the Twelve, dedicated the chapel on October 16, 1960. (Tufts Chapel.)

First Plymouth Congregational Church, established in Denver in 1864, moved from Fourteenth and Lafayette Street to a vacant plot of land at the southwest corner of Hampden Avenue and Colorado Boulevard in 1957. Ground was broken for the new church on November 24, 1957, and the cornerstone was laid on September 28, 1958. (First Plymouth Church.)

This westward view of First Plymouth Church shows the structure on November 30, 1958, two days after the first service. It is the sixth-oldest congregation in continuous service in Denver. Many parishioners did not own automobiles, so the church arranged for a bus to transport people on Sundays. (First Plymouth Church.)

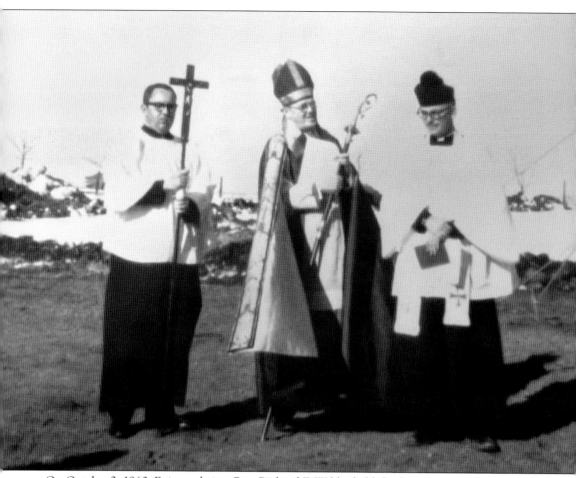

On October 2, 1960, Episcopal vicar Rev. Richard F. Wilder held the first service of Saint Gabriel the Archangel in the all-purpose room at Greenwood Village Elementary. Within two years of that first service, the mission grew to 82 families. Five acres of land were purchased by the Diocese of Colorado from the Bansbach family at 6190 East Quincy Avenue, and on January 27, 1962, the Right Rev. Joseph Minnis broke ground for the church building. The only home within view was the Bansbach home located on a hill across the gulch southeast of the new church site. Charlou remained largely undeveloped for several more years, and the church enjoyed an uninterrupted view of Pike's Peak to the south and Mount Evans to the west. The first structure was a small brick building on the east side of the property, which now houses the kitchen, nursery, library, and classrooms downstairs. The building was dedicated in September 1963. The Saint Gabriel the Archangel Episcopal Church groundbreaking ceremony was held on January 27, 1962, and led by Bishop Joseph S. Minnis (center), Reverend Wilder (right), and an unidentified person. (Saint Gabriel the Archangel Episcopal Church.)

In 1973, ground was broken for a new Saint Gabriel the Archangel Episcopal Church building to the west of the existing chapel. Dedication of the present worship space was performed by the Right Rev. William Frey on June 16, 1973. (Saint Gabriel the Archangel Episcopal Church.)

As shown here, 500 people attended the groundbreaking of the $2.5 million First Church of the Nazarene in October 1972 at Hampden Avenue and Colorado Boulevard. (Denver First Church.)

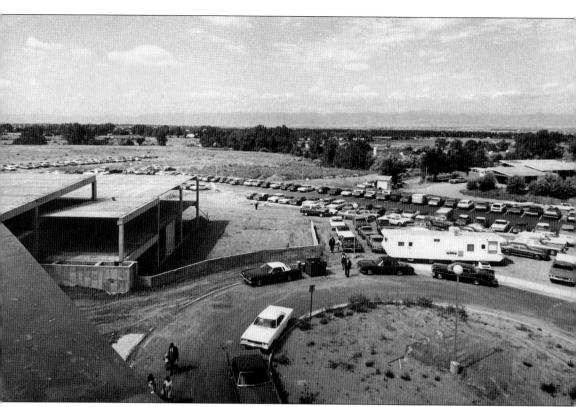

At the time of its construction, the First Church of the Nazarene was one of the largest churches in the western United States. In this 1973 image, construction of the 3,500-parishioner church is well underway. The church opened its doors on Easter Sunday, April 14, 1974, and the four-and-half-ton, 120-foot-tall steeple was placed by a large crane a month later. (Denver First Church.)

This is an aerial view of the Rolls-Royce Owners' Club at the 1928 Fisher and Fisher Tudor home of John W. Dick during an annual event that featured 42 Rolls-Royce and Bentley collector cars. The undeveloped Buell property is visible in the background in this 1974 photograph. (Dick family.)

Friends in period dress enjoy an afternoon at the Rolls-Royce Owners' Club event on the lawn of the John W. Dick Estate in 1974. (GT.)

The Glenmoor Country Club, pictured shortly after its opening in 1984, featured a Pete Dye–designed, Scottish "target golf"–inspired, 18-hole course on 112 acres; a 43,000-square-foot clubhouse; and 102 luxury single-family homes situated around the course's perimeter in its private, gated community. (Glenmoor Country Club.)

Ten

THE WOMEN OF
CHERRY HILLS VILLAGE

Really the women did more in the early days than the men. There was so much for them to do, the sick to take care of...There were so many men who could not cook and did not like other men's cooking and would insist on boarding where there was a woman.

—Augusta Pierce Tabor, 1884 interview

The lore of the American west is replete with romantic tales of solitary men—outlaws, gunslingers, cowboys, and marshals portrayed against the backdrop of the rugged frontier. The reality was different. Indigenous women often taught white men what to hunt and gather, as well as various other survival skills, and they acted as guides, offered alliances through marriage, and communicated and negotiated between cultures. These women also raised families and tended to every task on the frontier, including utilizing every part of the bison for food, shelter, and tools. Women from all cultural and socioeconomic backgrounds performed these tasks that contributed to a family's success and survival on the frontier.

In the 1880s, matriarch Kate Perryman ran her 19th-century family farm along present day Hampden Avenue at the High Line Canal alone after the death of her husband. According to her grandson John, Kate was "an indomitable English woman who still wore full floor-length mourning garb in memory of her long, long dead husband" but disliked talking about the past. On the Perryman farm, Kate raised livestock and chickens, grew and harvested a variety of fresh fruit and vegetables, administered frontier medicine, protected her family, and even negotiated and traded goods with the Arapaho.

Perryman's grit, resilience, will, and determination also characterize subsequent generations of women in Cherry Hills and throughout Colorado. Women established schools and hospitals, championed equality at the state and federal levels, built communities, supported the arts and culture, cared for the less fortunate, and presided over high society.

Women, concerned about inequality and the scourge of prostitution, voiced their opinions at the polls in the late 19th century, with sentiments borne in part from the streets of the demimonde districts around Colorado. The suffrage movement gained significant national attention after women's efforts were successful in Colorado.

Suffragist and socialite Margaret "Molly" Brown was a significant financial benefactor of St. Mary's Academy and one of the most prominent voices in Colorado's statewide suffrage movement. As a result of her campaign efforts, Colorado became the first state to enact women's suffrage by popular referendum on November 7, 1893. Brown's efforts in Colorado inspired other states to follow suit and eventually led to the passage of the 19th Amendment, which officially granted women the right to vote across the United States in 1920. (DPL.)

Persis McMurtrie Owen served on the Cherry Hills Village Board of Trustees and the Planning Commission. In 1948, she founded and became the first editor of the city's monthly publication the *Town Crier* (now the *Village Crier*). She and her husband, William R. Owen, built their Hoyt-designed English country home on South Gilpin Street in 1923. Persis demonstrated immense literary and artistic talent and studied at the Denver Atelier, during which time she published illustrated poems and drawings for *Childlife* magazine. She and William divorced in 1928, and Persis moved back to Denver, her birthplace, where she worked as a landscape architect between the 1930s and 1960s. Persis was actively involved in the Denver Art Museum and the Denver Botanic Gardens Guild, where she designed the herb gardens in 1965. These efforts earned her a place among Denver's elite as a preeminent landscape planner, and the Botanic Gardens bow-knot garden is dedicated to her legacy. Friends remember her evocative warmth and witty charm that was complimented by her grit and resourcefulness. In 1936, she purchased the former Lipmann property at the northeast corner of Quincy Avenue and Colorado Boulevard, where she lived the rest of her life. (HI.)

Early Cherry Hills residents developed innovative and decorative ways to transport their children during regular chores on the prairie. (DPL.)

Sisters Elnora and Helen Brady enjoy an idyllic afternoon with their dog on the Platte River and a view south toward undeveloped Cherry Hills from Hampden Avenue and Dartmouth Avenue in 1927. (EPL.)

Margaret "Madre" Dake Bansbach, born in Colorado in 1889, married Louis P. Bansbach Sr. in 1910. Margaret was a confident, socially prominent woman with disparate interests and talents and was a lifelong opera aficionado. A well-known philanthropist, she volunteered with the Red Cross Motor Service during World War I and was a board member for the Denver Orphans' Home. Margaret is pictured with her two children, Charlotte and Louis Jr., after whom the Charlou subdivision is named. (Bansbach family.)

Abby Staunton Shafroth (center) is seen on horseback with unidentified family members and local kids around 1928 at her farm at Belleview Avenue and University Boulevard, the current sites of Cherry Hills Farm neighborhood and the Glenmoor Country Club. Abby Staunton was an accomplished equestrian, active tennis player, and skier. Her larger-than-life persona made her the de facto social matriarch of Cherry Hills. She and fellow socialite Marj Buell (Temple Buell's wife) were known to raft down the High Line Canal engaged in a spirited conversation with hors d'oeuvres and Bloody Marys in hand. (DPL.)

By the 1920s, the automobile had eliminated the necessity for most families to keep horses. Denver's wealthy elite took a keen interest in country living and established acreage estates in Cherry Hills and around Denver, where they formed or joined riding clubs purely for pleasure. This group of women and their hunting dogs is preparing to go on a fox hunt in the 1920s. (DPL.)

In 1936, the *Denver Post* described Kistler Stables this way: "The horses . . . are show animals that have carried off honors at state, county and national exhibitions. The blue-bloods are housed and fed carefully and their daily exercise is as much concern to Mrs. [Florence] Kistler as to her daughter, Florence, who has established a reputation as one of the best horsewomen in the west." In 1937, the *Denver Post* heralded the rise of the social institution known as the riding club. Almost a dozen riding clubs operated across the metro area in the 1930s, including the Cherry Hills Saddle Club and Kistler Stables. Florence's other daughter, Frances, is pictured riding in front of her stable building in 1938. (Village Club.)

The Cherry Hills Club became the Cherry Hills Country Club in 1945 to better represent its membership as well as its social and golf activities. Here, three generations of well-dressed women and club members attend a social event in 1949. (HI.)

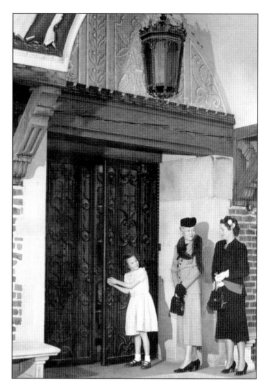

When longtime city clerk Elizabeth "Woodie" Noel (right) and her husband, Max, moved to Cherry Hills Village in 1946, east Hampden Avenue was a two-lane gravel road, and Colorado Boulevard was dirt-topped between Evans Avenue and Quincy Avenue. Only 450 families lived in the area, and about 85 students attended one grammar school—Cherry Hills Elementary. Woodie was city clerk from 1951 until she retired in 1992 as the city's longest-serving employee. Also pictured are, from left to right, Don Young (public works), judge Fred Powell, and chief of police Elliott Burke. (CHV.)

Ethel Gano and her husband, George, the cofounder of the Cherry Hills Country Club, built one of the first mansions in the area in 1919. Ethel predicted she would haunt her Cherry Hills home long after her death in 1960. It seems she was true to her word, as subsequent owners and guests have confirmed her continued appearances throughout the years. (Library of Congress.)

"Miss Gloria" Armstrong, theater performer and *Romper Room* host, entertains her youthful audience at the Cherry Hills Country Club as they await Santa Claus's imminent flight into Cherry Hills Village on Christmas Eve in 1962. (GT.)

In the spring of 1922, three teachers, Mary Kent Wallace, Mary Austin Bogue, and Mary Louise Rathvon, affectionately known as the Three Marys, went on a mountain retreat and returned with plans to open their own school. By the fall, the Three Marys had secured 13 faculty, 82 students, and a mansion-turned-school building at 933 Sherman Street in Denver's Capitol Hill neighborhood. On September 18, 1922, the newly christened Kent School for Girls—named for founding principal Mary Kent Wallace—held its first day of classes. Within 30 years, demand for spots at the Kent School exceeded the capacity of its Sherman Street campus. In January 1951, the Kent School moved to a new campus at 3401 South University Avenue at the northwest corner of University Boulevard and Hampden Avenue. (Kent Denver.)

After Cat and Keith Anderson purchased Quincy Farm in December 1964, Cat established the Cherry Creek Pony Club, which she ran for over 25 years. Pony Club taught young local riders all aspects of equestrianism, including care, feeding, and competition. The Andersons lived in the property until Keith's death in 2005 and Cat's in 2007. Cat created a conservation easement and life estate that deeded the remaining 17.5 acres to the city of Cherry Hills Village upon her passing. Below, Cat jumps an obstacle on her horse Sylvia. (CHV.)

Jane Cottrell Little, wife of the first mayor of Cherry Hills, Joe Little, was the daughter of George Cottrell, founder of the Cottrell Clothing Company in Denver. (HI.)

Cherry Hills residents and philanthropists (from left to right) Pat Forrest, Gene Koelbel, and Margot Grant enjoy an afternoon with Dolly, a 15-year old elephant at the Denver Zoo. (Koelbel family.)

Actress and singer Ethel Merman was known as the "undisputed First Lady of the musical comedy stage" and performed Broadway hits such as *Hello, Dolly!*; *Annie Get Your Gun*, and *Stage Door Canteen*. She is pictured with her husband (and Continental Airlines CEO) Robert Six. Soon after their marriage in 1953, they moved into a 27-room Cherry Hills mansion, the former J. Churchill Owen estate in the Country Homes subdivision, where they lived until their divorce in 1960. (HI.)

This photograph was taken during Princess Anne's (right) visit to Colorado and shows her with Temple Buell's daughter Callae Gilman (left) and her husband, Atwill "At" Gilman (center), at their home at Colorado Boulevard and Quincy Avenue. At removed the original 19th-century outhouse from the property just prior to the princess's trip. Friend and Cherry Hills Village resident John W. Dick loaned the princess the blue Rolls-Royce Silver Spur (pictured) from his collection for her to use during her nine-day visit in June 1982. (GT.)

In addition to the multitude of important tasks that women performed in the late 19th century including raising children and managing the homestead, they also worked jobs that involved long hours and extensive physical exertion. This group of cherry pickers, clippers and pails in hand, pose in a cherry orchard near Denver around 1900. The group, comprised of mostly women of all ages, spent the work day clipping and filling wooden crates with fresh, ripe cherries. (DPL.)

Bibliography

Articles of Incorporation, By-Laws, Rules, Officers, and Members of The Denver Country Club, 1947. Denver, CO: The Denver Country Club, 1947.

Brenneman, Bill. *Miracle on Cherry Creek.* Denver, CO: World Press, Inc., 1973.

Brown, George III. *Cherry Hills Country Club, 1922–1997.* Cherry Hills Village, CO: Cherry Hills Country Club, 1998.

Cherry Hills Club, 1926. Denver, CO: Cherry Hills Club, 1926.

Davis, Sally, and Betty Baldwin. *Denver Dwellings and Descendants.* Denver, CO: Sage Books, 1963.

Goe, Donald K., and Clarice M. Crowle. *The History of the Cherry Creek School District Number Five, 1869–1981.* Englewood, CO: Cherry Creek School District, 1981.

Goetzmann, William H., and William N. Goetzmann. *The West of the Imagination, Second Edition.* Norman: University of Oklahoma Press, 2009.

Leonard, Stephen J., and Thomas J. Noel. *Denver, Mining Camp to Metropolis.* Denver: University Press of Colorado, 1990.

McAlester, Virginia, and Lee McAlester. *A Field Guide to American Houses.* New York: Alfred Knopf, Inc., 1984.

McGrath, Maria Davies. *The Real Pioneers of Colorado, Volume I.* Denver: The Denver Museum, 1934.

Mosch, Alvin. *Gold Dust, Dreams & Life of a Miner: True Short Stories & Gold Mining Adventures From the Secret Diary of Alvin Mosch.* Idaho Springs: Self-published, 2008.

Noel, Thomas J. *Colorado Catholicism and the Archdiocese of Denver, 1857–1989.* Denver: The University Press of Colorado, 1989.

Noel, Thomas J., and Barbara Norgren. *Denver: The City Beautiful & Its Architects.* Denver: Historic Denver, Inc., 1987.

Noel, Thomas J., and Deborah B. Faulkner. *Colorado, An Illustrated History of the Highest State.* Sun Valley: American Historical Press, 2006.

Norland, Jim. *Fifty Years of Mostly Fun, The History of Cherry Hills Country Club, 1922–1972.* Cherry Hills Village, CO: Cherry Hills Country Club, Inc., 1972.

St. Mary's Academy, 150 Years. Boulder, CO: Bristlecone Books, 2014.

VanderWerf, Klasina. *High on Country, A Narrative History of Cherry Hills Village.* Cherry Hills Village, CO: The Cherry Hills Land Preserve, 2007.

West, Elliott. *The Contested Plains, Indians, Goldseekers, and the Rush to Colorado.* Lawrence: University Press of Kansas, 1998.

DISCOVER THOUSANDS OF LOCAL HISTORY BOOKS FEATURING MILLIONS OF VINTAGE IMAGES

Arcadia Publishing, the leading local history publisher in the United States, is committed to making history accessible and meaningful through publishing books that celebrate and preserve the heritage of America's people and places.

Find more books like this at
www.arcadiapublishing.com

Search for your hometown history, your old stomping grounds, and even your favorite sports team.